SO MANGA BABES

TO DRAW AND PAINT

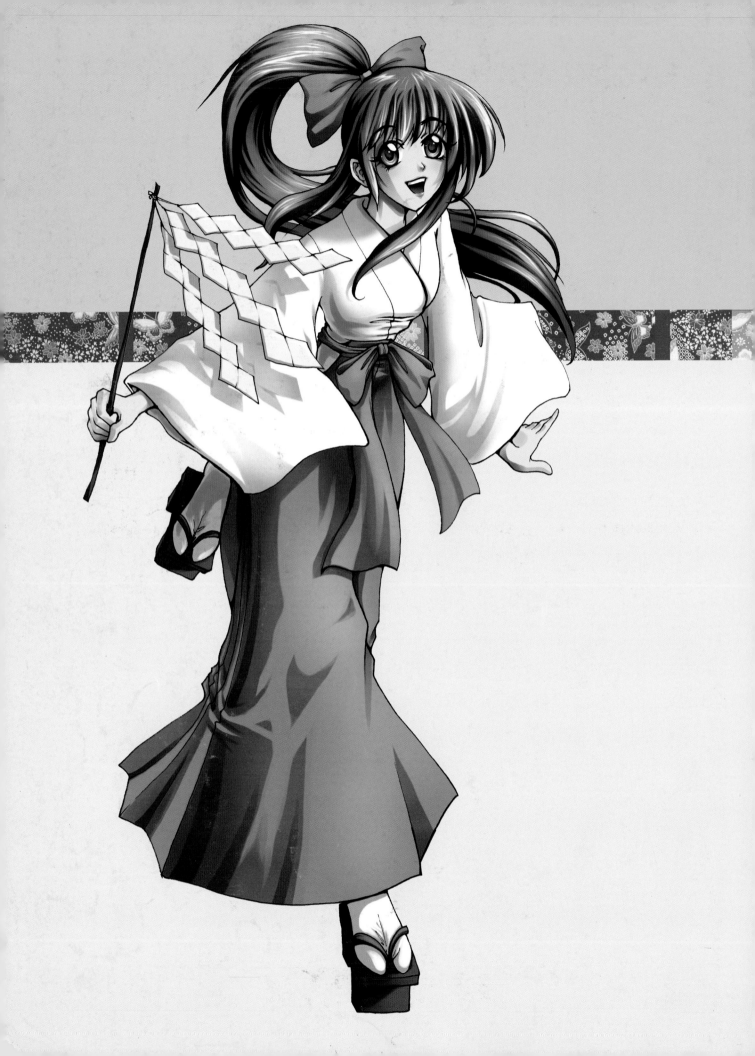

50 MANGA BABES
TO DRAW AND PAINT

CREATE CUTTING-EDGE MANGA FIGURES FOR COMIC BOOKS,
COMPUTER GAMES, AND GRAPHIC NOVELS

CHI HANG LI

WITH A CONTRIBUTION FROM JANET BENN

A QUARTO BOOK

Copyright © 2008 Quarto Inc.

First edition for the United States and Canada published in 2008 by Barron's Educational Series, Inc.

All inquiries should be addressed to:
Barron's Educational Series, Inc.
250 Wireless Boulevard
Hauppauge, NY 11788
www.barronseduc.com

ISBN-10: 0-7641-3810-3
ISBN-13: 978-0-7641-3810-2

Library of Congress Control Number: 2006940783

QUAR.FBA

Conceived, designed, and produced by
Quarto Publishing plc
The Old Brewery
6 Blundell Street
London N7 9BH

Project editor: Lindsay Kaubi
Copy editors: Leah Holmes, Matt Ralphs

Art director: Caroline Guest
Art editor: Natasha Montgomery
Designer: Karin Skånberg

Creative director: Moira Clinch
Publisher: Paul Carslake

Manufactured in Singapore by Provision PTE Ltd
Printed in China by 1010 Printing International Ltd

9 8 7 6 5 4 3 2 1

Contents

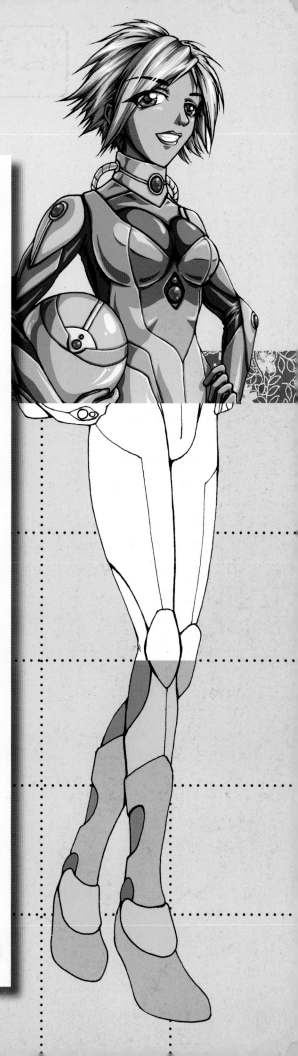

Introduction

Manga, the popular Japanese graphic novels and comic books, have precipitated an explosion of new manga-style art in print, in the movies, and on television. *50 Manga Babes to Draw and Paint* introduces 50 specially designed female characters to demonstrate and teach manga female character design. The characters in the book represent manga genres ranging from realistic and lifelike to exaggerated and distorted, each showing manga style in a different way.

50 Manga Babes to Draw and Paint is designed to take you, step-by-step, through female manga character design, covering a comprehensive list of female character types, from traditional older ladies who are ex-babes and popular fan favorites, such as schoolgirls and French maids, to child and chibi characters who are closer to being babes in arms!

First, take some time to absorb the principles of character design in the first chapter, then go on to the second chapter, where babes drawn by a range of different artists demonstrate the spectrum of possibilities, and pick your favorites to emulate. Characters can be successfully recreated by following the steps shown here. With practice, you will soon be designing your own manga babes!

About this book

This book is arranged into two chapters: first, techniques, which gives advice on inspiration, choosing different media, using different media, and rendering clothes, and, second, the heart of the book, a chapter providing explanations on how to draw and paint 50 specially designed manga babe characters. This chapter is organized into eight subsections: fan favorites, warrior women, Japanese traditions, street fashion, fantasy femmes, girls next door, career girls, and super cute.

Character studies

For each babe, character studies show her head from the front, three-quarter view, and profile, including facial expressions. Learning the character in three dimensions helps two-dimensional drawing because you can see the character from any angle in your mind's eye.

Finished artwork

Each babe is shown as a final, full-sized artwork.

Scan or trace this!

You can scan or trace the line art stage or draw it from the book.

Details

Visual character details that add interest are listed. These vary from character to character, but include information on details such as accessories, clothes, hair, and skin tone.

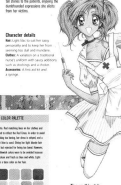

Demonstration

The demonstration panel takes one aspect of the final art from outline to finish, with detailed descriptions of the techniques used at each stage.

Color palette

A color palette created uniquely for each character is shown in full along with notes on which colors were chosen and why.

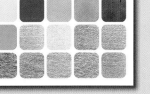

Artwork stages

Each of the major steps in the character's creation is shown: first, a polished outline; second, color fills; third, the shading and finishing details. Studying the finished art and reading the Demonstration panel will help you decide on a rendering technique.

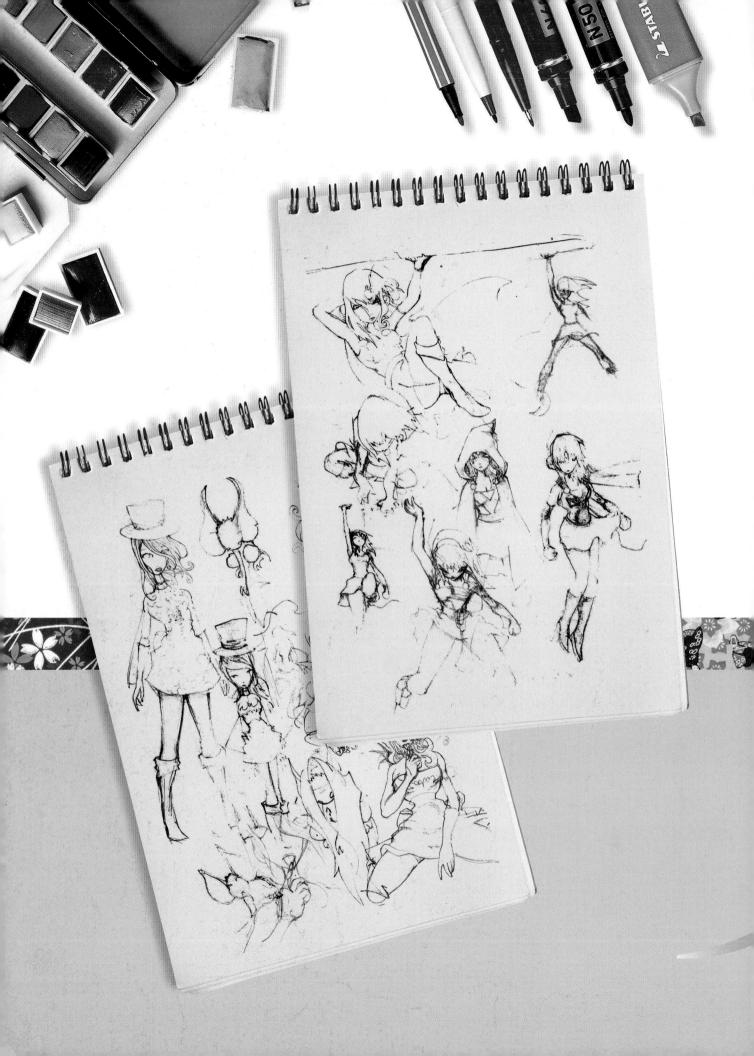

CHAPTER 1
Manga babe techniques

In this chapter, you'll find everything you need to get started on designing and rendering your own manga babe, from where to find inspiration to what tools and materials to use. All traditional and digital rendering techniques are explained, and character design concepts, such as proportion and color, are discussed, along with essential information on traditional Japanese attire and handy tips on drawing folds in clothing.

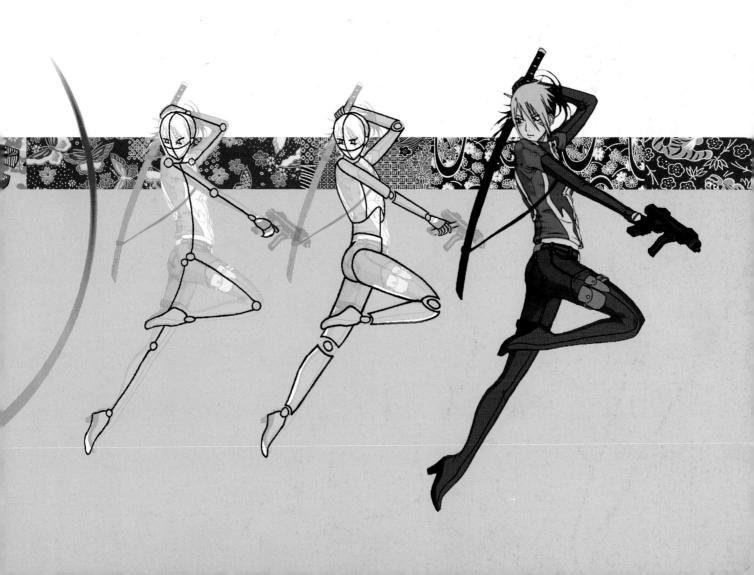

Inspiration

Inspiration is the result of being touched by things around you and being able to recognize how they affect you. Write down your ideas, or draw them in a sketchbook. If manga art is your goal, then here are some resources to help guide you. It should be noted that inspiration and taste is highly subjective and that these resources should be seen as a starting point rather than as a definitive list.

Movies you must see

The movies listed here are important both as inspiration and visual reference. In the animated movies, manga artists can see strong female heroes and groundbreaking design. The classic *Seven Samurai* shows Japanese history and culture. *The Matrix* trilogy delivers all of these and an impressive science fiction universe.

Animated movies

Akira (1988)
Directed by Katsuhiro Ôtomo
Ghost in the Shell (1995)
Directed by Mamoru Oshii
Princess Mononoke (1997)
Directed by Hiyao Miyazaki
Spirited Away (2001)
Directed by Hiyao Miyazaki
Metropolis (2001)
Directed by Rintaro (a.k.a. Hayashi Shigeyuki)
Animatrix (2003)
Directed by Peter Chung, Andy Jones, Yoshiaki Kawajiri, Takeshi Koike, Mahiro Maeda, Koji Miramoto, Shinichiro Watanabe

Conventional movies

Seven Samurai (1954)
Directed by Akira Kurosawa
Crouching Tiger, Hidden Dragon (2000)
Directed by Ang Lee
The Matrix Trilogy (1999–2003)
Directed by the Wachowski Brothers

Books you must read

Japanese manga stories often take ideas from fairy tales and mythology. Absorb these, but also revisit your own cultural sources. Joseph Campbell will help put it all together and advance you into a world of your own creation.

Japanese Folk Stories and Fairy Tales
By Mary F. Nixon-Roulet
American Book Company (1908)
Folktales from Japan (web site)
Selected and edited by D.L. Ashliman
Online: www.pitt.edu/~dash/japan.html
Oriental Mythology
By Joseph Campbell
Part of *The Masks of God Series*
Penguin Group (1991 new edition)

Manga you must read

These manga have been translated into English in recent years, so they are still in circulation, even if they originated in the 1960s. Some are still bestsellers. Titles aimed at girls ("shoujo" in Japanese) feature romantic themes with thoughtful women. Those for boys ("shounen" in Japanese) also have strong women characters. The number of volumes refers to the Japanese versions, and they may not be available in English. The titles are in chronological order.

Lupin the Third
By Monkey Punch (a.k.a. Katou Kazuhiko)
(14 volumes) from 1967 Shounen

Urusei Yatsura
By Rumiko Takahashi
(34 volumes) from 1978 Shounen
Nausicaä of the Valley of the Wind
By Hiyao Miyazaki
(7 volumes) from 1982 Shounen
Ranma ½
By Rumiko Takahashi
(38 volumes) from 1987 Shoujo
One Piece
Eiichiro Oda
(46 volumes) from 1997 and ongoing Shounen
Fruits Basket
Natsuki Takaya
(23 volumes) from 1998 Shoujo
Phoenix
By Osamu Tezuka (1928–1989) (12 volumes) called his "life work" by the author, 1956–1958

Artists you must know
Japanese creators of manga and anime

Osamu Tezuka
Tezuka created more than 700 manga series and headed an animation production studio that pioneered TV animation in Japan.

Major Motoko Kusanagi from the anime *Ghost in The Shell*, the visually stunning adaptation of Masamune Shirow's science fiction manga.

Japanese words to know

Anime: The Japanese word for animation. The short form of the Japanese pronunciation of the English word "animation."

Bishoujo: This means "pretty girl." Any manga that predominantly features pretty girls is considered bishoujo.

Bishounen: This means "beautiful boy." An art style used in shoujo manga and anime, where boys and men are drawn to be "pretty" and elegant rather than rugged and handsome.

Chibi: This word describes "a small thing or a person with a small body," like a young child.

Doujinshi: Manga that are nonprofessional and/or self-published. Some professional artists also make doujinshi. They are made as homages to another manga or produced as original ideas.

Kawaii: Literally means "cute, charming, or lovely," but in common Japanese usage it often describes a bit more than "cute," including an element of liveliness or happiness in the object.

Seinen: Word for "adult male," for anime and manga aimed at a young adult male (college-aged) audience.

Sensei: This word describes a teacher, or a master of a certain discipline. It can also refer to a doctor, and is used as part of that person's family name when addressed—for example "Otomo-sensei."

Shoujo: Japanese for "daughter or young girl," and is used to classify anime and manga aimed at girls. There is a popular subgenre of shoujo called Mahou Shoujo or "magical girl."

Shoujo-ai: This word, meaning "girl-love," refers to stories that feature romantic ties between female characters that don't include sex.

Shounen: The word indicates anime and manga aimed at boys. The most obvious and common example of shounen is "fighting" anime, although giant robots or mecha, are also a very common form.

Shounenen-ai: This Japanese word, meaning "boy-love," refers to stories that feature romantic ties between male characters that do not include sex, but only love and romance.

SD or Super-deformed: Super-deformed characters (SD for short), have large heads and short limbs, so they appear cute and funny. It also means a transformation occurring as the visual indication of an emotionally charged state.

Hiyao Miyazaki
Animation feature film director: *Spirited Away* (2001), *Princess Mononoke* (1997), and *Kiki's Delivery Service* (1989), among others.

Katsuhiro Ôtomo
Author and artist for groundbreaking *Akira* (1884) feature film and manga

Clamp
A Japanese artists' collective of four women: Satsuki Igarashi, Ageha Ohkawa, Tsubaki Nekoi, and Mokona. Creators of manga titles: *Cardcaptor Sakura*, *Tokyo Babylon*, *xxxAholic*, *Rayearth*, and others.

Rumiko Takahashi
Arguably Japan's most famous manga artist: author of works such as *Urusei Yatsura*, *Mezon "maison" Ikkoku,* and *Inu-Yasha*.

Akira Kurosawa
Japan's greatest film director: *Seven Samurai* (1954), *Ran* (1985), and many others.

Selected OAV series
Original Animation Video and Original Video Animation (OAV/OVA) are interchangeable terms used for animation released directly to the video market. This list includes both best-selling and critically acclaimed works, and is skewed toward stories featuring women.

Neon Genesis Evangelion
Critically acclaimed, this science fiction drama is based on a T.V. series. The main character, Mecha pilot Shinji Ikari, is a 14-year-old boy living in the fortress city of Toyko3.
www.advfilms.com

Vampire Princess Miyu
Spiritualist Himiko Se finds herself involved with the supernatural when she comes face-to-face with a young vampire girl known only as Miyu. A unique anime that is a classic of its genre.
www.animeigo.com/Products/

San (Princess Mononoke) is riding into battle on her foster mother, the wolf goddess Moro: from the award-winning film *Princess Mononoke* by Hiyao Miyazaki.

Oh! My Goddess
A humorous story of Keiichi, a young man who has been granted a wish by a visiting goddess named Belldandy. The storyline spans the original manga and the later 2005 T.V. series.
www.animeigo.com/Products/

Books on manga history
500 Manga Heroes and Villains
by Helen McCarthy
Barron's Educational Series (2005)

Manga: 60 Years of Japanese Comics
by Paul Gravett
Collins Design (2004)

Manga! Manga!: The World of Japanese Comics
by Frederik L. Schodt
Kodansha International (1997)

Western distributors of manga

Tokyopop
American publishers of OEL (Original English Language) manga, such as: *Dramacon*, by Svetlana Chmakova; *Sorcerers & Secretaries*, by Amy Kim Ganter; *Peach Fuzz*, by Jared Hodges and Lindsay Cibos.

Viz Media
Major American anime, manga, and Japanese entertainment company. Its many titles are featured in two magazines: *Shojo Beat* and *Shonen Jump*. Other notable properties include *Fullmetal Alchemist* and *Tenchi Muyo!*

Tools and materials

You can begin drawing manga babes with widely available, simple tools and materials. As you gain experience, you can experiment with more specialized items. Quality materials are a good investment, but you do not have to buy much to get started. Frequent visits to art stores and stationers will familiarize you with what is available. Many manga artists use traditional methods up to the finishing stages, then switch to the computer, using a drawing tablet or scanner as an input device. Most professionals learned to draw and paint by hand, and then incorporated digital techniques gradually.

Beginner's toolkit

Select papers. All-purpose and/or photocopy paper for pencil work. Choose from brands like Staples, Hammermill, and Xerox. Smooth Bristol paper for inked and colored work. Strathmore 300 Series Bristol Board Pads. Bienfang Bristol Board Pads.

Artists' drawing pencils. One each HB, B, and 2B grades. Choose from brands like Derwent, Staedtler, Tombow, Faber-Castell, Sanford, and General.

Erasers. One kneaded eraser (won't damage paper) and one in white plastic or vinyl (allows erasing with more pressure).

Good electric pencil sharpener. Choose from brands like Boston, Xacto, and Dahle.

Art utility knife. Sharp, replaceable blades.

Artist-grade colored pencils. Choose from brands like Derwent Studio or Sanford Prismacolor. Also nonphoto blue or erasable colored pencils. Choose from brands like Staedtler and Sanford Col-erase.

Watercolors, watercolor pencils, colored inks, and brushes. Choose from brands like Winsor-Newton, Grumbacher, or Dr. Ph. Martin's.

Flexible nib dip pen.
Black waterproof permanent ink.

Inking pens. Marker pens such as Sakura Micron pigment markers in three sizes: 0.3, 0.5, 0.8 mm.

For coloring, choose permanent studio markers. Choose from brands like Copic, Chartpak, or Letraset Tria.

Light box.
Fluorescent light bar for tracing rough pencils for finishing.

Expanded toolkit

• Computer workstation with tablet and/or scanner and printer.
• A good desktop computer with a fast processor, good graphics card, and plenty of file storage.
• Graphics tablet for drawing directly into the computer.
• Flatbed photo-quality scanner with largest scanning glass possible.
• Color inkjet printer able to handle several different papers.

Most widely used software for full-color work:
Adobe Photoshop
Adobe Illustrator
Corel Painter
openCanvas

Most widely used software for black-and-white work:
Deleter Comicworks
E-Frontier Manga Studio

Workspace

The most important feature of your workspace is comfort.
• Start with a table, a chair, and a good light.
• Add a slanted drawing board later.
• You will need a side table for your pencils, pens, and colors.
• An adjustable chair on wheels is best for comfort.
• Shelves or cupboards will hold most other supplies.

Colored pencils

Colored pencils achieve paint effects without any supplementary supplies. Although there are colored pencils that can be used wet—with solvents such as turpentine or water—the most common technique is layering: building up tones with light, even applications of two or more colors. Pencils are translucent, so the layers create subtle color variations. Through successive overlays, tonal density and contrast can be controlled to produce three-dimensional forms. Study the "Grandma" character (page 58), especially her clothing, to see these techniques.

PAPER

When buying good paper, examine examples used for watercolors and for drawing. Some artists like a rough paper than breaks up the color revealing the texture of the paper. Others like smooth paper that allows the pencils to apply all the textural qualities. Manga-style illustrations are usually composed on smooth, finished paper.

Practice mixing colors

Mixing colors with colored pencils is not the same as when doing so with paint. You must use lighter colors first, working lightly with the pencil, in small circles. Put down an even layer of pencil. Use a good quality pencil, as cheaper ones will not have enough pigment.

To make a light blue-green color, start with a soft blue, then a soft green. Add a layer of soft white to lighten and blend the blue and green together. Gradations from one color to another can be made by lightly overlapping colors. Then blend by adding white. Repeat until perfect.

Overlaid patches of grainy shading produce subtle mixtures and gradations of color. This sample (left) contains four colors: yellow, yellow-ocher, green, and gray-blue.

An alternative method of blending is to use the technique of crosshatching. Apply a different color each time you change the direction of the sets of hatched lines.

Erasing and highlights

To remove or blend a color, use a hard pink or white eraser; it is difficult to remove color entirely, because there is wax in the pencil. Work on light areas first, then darker ones. Light colors will not affect dark colors if applied on top, so apply dark colors last. Shade in the color slowly, working up to, and around, the highlighted areas, in order to keep blank areas of paper clean. To avoid smudging, keep your hand away from the drawing or cover the drawing with a piece of paper. More highlights can be applied later with opaque gouache paint, pastel, or chalk pencils.

Blending

Sometimes colorless blender markers (solvent-based) can be used to liquefy the wax pencil colors, which will be absorbed by the paper. Usually, dry colorless blender pencils are used because they carry a chemical to the wax-based pencils that blends colors.

Waxy pencil colors do not spread easily, so you need to create a blend by working one color over another. When shading, keep the pencil strokes even and work them in the same direction in each color area (above).

Shading

There are many ways to shade, all of which contribute a sense of volume to your drawing:

Use a darker color over another to produce interesting textures.

Overlay a linear pattern of lines over flat colors; this is called "hatching"(below).

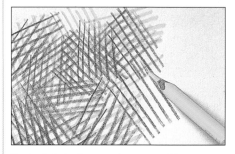

Graduated shading can be created by gradually lessening the pressure on the pencil (below).

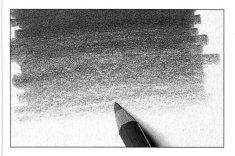

Before adding color, develop a complete drawing in shades of gray. This is called "grisaille," and has the advantage of supplying a fully developed shadow pattern before the translucent color is applied.

• Spray a fixative over graphite drawing, then add color or

• Xerox a value drawing onto another piece of paper, then add color.

Marker rendering

An important art technique to master is using markers to quickly and efficiently complete artwork. This technique uses permanent (solvent-based), nontoxic, wide felt-tip markers, which are available in a tremendous range of colors. Some marker brands have interchangeable tips or are equipped with two tips (or "nibs") for making fine lines, as well as color-filling areas. Brush-tipped markers are designed to mimic paintbrush color application. Check the marker's chemical composition: some are water-based, which offers a different set of manipulative techniques.

Clear outlines

For outlines, use a fine-line marker that will not react with markers used for the interior areas. Ensure that the outline marker does not blend with the solvent-based color marker, as this causes ugly streaks and loss of the outline's crispness. Test the markers in the store before purchasing. Not all "marker proof" fine liners really work. However, a water-based fine-line marker will not normally react with a solvent-based color marker. The most popular permanent color brand for manga is Copic Markers used throughout Japan. They are sold in comic shops throughout Asia, and have spread to Europe, the U.S., and Canada.

Using markers for color

All markers apply a direct and immediate band of color to paper. They are convenient because no advance preparation is needed. They are unforgiving, once applied the color cannot be removed and subsequent manipulation is limited.

For each base color have two or three shades of that color, from dark to light, for blending. Leave the white of the paper showing where you want the brightest highlights. This requires forward planning, before you lay the colors down on the drawing; you cannot erase any mistakes. You might be able to remove some color with a fresh, wet, clear blending marker, but do not count on it!

Blending

Go from light to dark when applying colors. Blend by applying the darker colors over the lighter color when the first color is still wet; the two colors will "bleed" into each other, causing a soft transition.

TIPS ON MARKER RENDERING

To achieve a definite demarcation between colors: Let the first colors dry before applying any more; study "Pai the Cute youth" (page 92) to see where this application has been used. Examine her arms and legs, her dress and hair: see how the shadow tones against the base colors have a sharp edge.

Don't overuse markers: Do not make the common mistake of overusing markers, filling in every area with color or mixing colors together. Your renderings should make your manga girls interesting and natural looking. Decide where the primary light source is, and plan highlights and shadows accordingly. Do not use pencil lines to define these because marker color is transparent and any pencil lines will show through.

Study the color application on "Ying the Martial artist" (page 46): Notice the proportion of light to dark areas and the amount of base color applied. Examine the amount of exposed white paper. It does not take much color to demonstrate Ying's energy, as her active stance already implies motion. She seems to be jumping off the paper at you!

Using markers

Brush-tip pens are designed to mimic watercolors. Their marks vary in thickness according to the amount of pressure applied.

Fine liners make a uniform mark of a consistent width and are very useful for outlines.

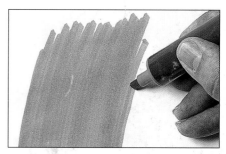

Wedge-tip markers add a direct and immediate band of color to your artwork, and can be used for smooth and continuous tone.

Watercolors

Artists' quality watercolor paints sold in tubes are expensive. Try to find good quality paint sets in pans. If properly cared for, these will last for years. Never mix paints on the pans, and remember to dab your paint pans with a paper towel and allow them to dry before closing the box. Liquid watercolors contain dyes as well as pigments and are especially brilliant and transparent. Watercolor pencils can be used wet or dry, and are particularly useful in small areas where brush control is difficult. They can also be used to add details or textures on top of dried watercolor paint.

Brushes

Buy the best brushes you can afford, because they are the most important tools for achieving success in watercolor painting. The bristles come from various animals: red sable is the best, followed by sabeline (a form of ox hair), ox hair, camel, and squirrel hair. The last two are not desirable. Synthetic materials are also used: white nylon falls below ox hair, but above camel hair in quality.

Watercolor brushes are either shaped into a round or a flat bundle. When wet, round brushes should hold a point. Flat brushes are used to wash areas evenly with one color. A number eight sable round brush is the first quality brush you should buy. Larger flat brushes do not have to be the best quality, but they must brush smoothly, and not deposit hairs on your work.

Transferring line art to watercolor paper

Preparing your drawing for painting is easily done by tracing the rough drawing onto good paper over a lightbox with a firm-leaded pencil. As you are going to wet the paper, ink is not recommended, although some ballpoint pens will not spread when wet.

OTHER SUPPLIES

Water container	Palette tray
Clean paper tissues	Transfer paper
Kneaded eraser	Painting board
Brush carrier	Brown paper tape

If you do not have a lightbox, or if your paper is too thick to see through, you can transfer the line art onto the paper using transfer paper, which comes in shades of blue or black. Fix the watercolor paper to a flat surface, tape the transfer paper on top (leaving a corner and sides free so you can check your progress), and clip or tape your sketch on top of everything. Using a sharp pencil with a hard lead, retrace your lines. The transfer paper will leave a line where you traced. Check your pressure and your progress, and continue until the drawing is all on the watercolor paper.

Strokes and brush control

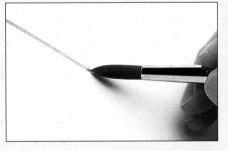

When using watercolors, strokes should be continuous. You cannot correct watercolor because it is transparent and will show all strokes. You can cover paint with gouache–a kind of opaque watercolor–although it is easy to muddy up the colors unless used carefully.

Hold your brush firmly, but loosely enough to ensure that your muscles do not get tired, causing your hand to shake. Rest your little finger on the paper to steady your hand if necessary. Be careful of touching wet paint–if needed, use a clean paper sheet to protect your dried paint areas from smudging. Study the "Princess" manga character (page 32), especially the shadows on the skirt. Her delicate white dress details were added to the blue color with white gouache.

Preparing a Paper

The first step in painting is to take your watercolor paper with the drawing on it, and wet it down. The best way to prepare the paper is to soak the entire piece in a pan of clean water, smooth it over a flat board (finished wood or masonite is best), and tape it all around with brown watercolor paper tape, which is only sticky when wet. Paper prepared thus will not buckle or shrink when wet, and your artwork will be perfectly flat when dry.

Highlights and shadows

Paintings should be built up in layers. First, cover the area to be colored with a light wash, using little pigment and lots of clean water on the brush. Leave some spots of white paper for highlights if desired. Once that part is dry, add shading on top with a darker color. The main rule with watercolor is: do not overdo it! Adding more layers will usually make any problems worse. Go on to the next area and reconsider when everything is done and dry.

Combining media

Sometimes it's most effective to combine a variety of media in one artwork (see "Cyborg," page 70). When doing this, it's important to know how they will interact. The solvents in markers might smudge some other inks, and water in watercolors could potentially blur line art; however, used smartly, combined media can achieve great results.

Drawing outlines

Permanent pigment fine-liners

Outline your character with Sakura Pigma Micron pens or Copic Multiliners. These are fine-point pens that will not fade or bleed. When dry, they are permanent and waterproof. Sakura pen points come in three sizes: 01, 03, and 05. Most artists start with the 05 point. Keep the caps on the pens between uses, so they do not dry out. Copic Multiliners come in six dark colors and black, and offer a variety of nib types and point widths. Prismacolor Premier Fine Line markers also offer colors, and several pen widths. Look for inks that are "archival" or "lightfast" as these will not fade over time. (See "Diva," page 116.)

Drawing pens

Fine-point markers or fine liners come in a variety of inks. Not all drawing pens are made to combine with other media. "Regular ink" does not mean waterproof. Waterproof ink is opaque, and is not soluble in water once it has dried. "Water-resistant" ink might smear when touched with water.

Pens are available with "waterproof India ink" in many colors, which can be blended when wet and dries transparent. Many new color inks are lightfast and acid-free, so your rendering will last almost forever! Most will not smear when overlaid with a permanent, solvent-based marker. (See "Festival girl," page 54.)

Ballpoint pens

A black office-type ballpoint pen will produce a fine line, although not thinner than a 01 Pigma Micron pen. The ink flow should be steady, with no clumps of ink or skips in the line. Many ballpoints have a dark gray ink, not as black as the artists' pen. These can be used for fine details that do not have to be dark black–such as hair or clothing folds, buttons, or laces. Have a paper towel handy to wipe the pen point before starting another line or after an interruption, as the ink will often form a blob on the tip of the pen. It will not smear when water is applied. The solvent in permanent markers, however, might spread ballpoint pen ink. (See "Princess," page 32.)

Adding color and shade

Watercolor markers and brush tips

Water-based, fiber-tipped drawing pens with water-soluble, washable ink can be applied safely over permanent solvent-based markers. Water-based markers are transparent, and can be blended with water to create new color gradations and clear washes. Stabilo Point 88 and Staedtler Triplus are both quality brands of fine-liner pens. Water-based markers also come with broad chisel point or medium-sized bullet point nibs. Many are available with brush tips, such as Art-kure and Bienfang brands, and are made to mimic the action of watercolor brushes. (See "Flower maid," page 100.)

Hard-colored pencils

Colored pencils used to fill in large colored areas are not always suited for fine lines and delicate details. Harder color leads will hold a sharper point longer. Derwent Studio and Prismacolor Verithin pencils are examples. (See "Grandma," page 58.)

Fine-point permanent markers

Permanent solvent-based markers also come in fine-point versions, such as the Sharpie and Pilot brands. Many chisel-point artists' markers come with fine points. This type of marker can be used on both line art and for color and shading. Note that the term "permanent" does not mean "lightfast," so check your product specifications if this is important in your application. (See "Cyborg," page 70.)

Pastels

Pastels can be used for coloring manga-style art, as long as the application is controlled. You do not want dust from the sticks to interfere with other detailed areas. Instead of putting the sticks to the paper, apply the color to a paper stump and rub it onto the drawing. (See "Fairy," page 76.)

Paper stump

Creating great line art

The first phase in completing a manga piece is to finish a clean outline drawing. Manga art is based on cartooning techniques: the first rough sketches are redrawn and refined with pencil, then traced onto a clean page with pen. The stylus of the digital drawing tablet often replaces the pen today, and with enough practice, a fine pen line can be achieved.

Drawing with pencils

Mechanical pencils with refillable leads are the best for transforming Stage 1 roughs into a precise Stage 2 line drawing, for coloring by hand, or by computer. "H" on a lead means "hard," with 6H being the hardest. "B" is for soft (think of "blendable") leads. 2B to 6B are most popular for quick sketches, as they glide over the paper without much resistance. Some artists use these in mechanical pencil holders for life drawing, though wooden pencils or graphite sticks in similar grades are more common.

The mechanical pencil is meant for precision. Practice using it with different leads, to find the grade that most suits you. Leads are made in different thicknesses, from .03 mm to 1 mm, with .05 mm and .07 mm being the most popular. The size of the lead will also make a difference in the results you get: consider this feature along with lead hardness when you are trying to find the best combination for your hand.

Stage 1: rough sketch or thumbnail sketch

Thumbnail sketches are preliminary drawings, usually quite loose, done quickly to capture a character's stance and overall proportions. They can be small, and are often made on odd scraps of paper or in the blank spaces of script pages.

Stage 2: cleaned-up sketch

Sketches are more detailed and controlled than thumbnails, and are usually drawn to the same size as the final work. A cleaned-up sketch is used as the basis for the final inked outline drawing. Sometimes the sketch is reproduced with such clean pencil lines that it is used instead of an inked copy for coloring.

Inking

Inking is a skill that takes time to master, but it is important that you do so. As with the pencil, the way you apply ink should be carefully considered. The angle of your drawing board, the ink instrument, the pressure of your hand, your arm, and hand muscle control— and the amount of coffee you drink in the morning!—all affect the lines' quality.

Line variation is a matter of personal taste. Most good manga-style art uses lines of varying thickness to add dynamism and a hint of the curvature and volume of the area being defined and enclosed. A character's form and pose is further accentuated by a "lifelike" inking job. Colors and shading impact the final art, but it is the quality of the ink line that sets the best manga art apart. Study the art in this book to see which ones really seem to leap off the page with energy, and see how varying line thicknesses achieves this effect. Other characters with active poses may suffer from unvarying line quality.

Lines on the outside of a shape are usually thicker than lines inside. Lines look best when heaviest at the fullest part—or top of the line— then taper to a point. Consider which shapes are behind or in front of others: use tapering points to bring the eye around from the back to the front or to ease the transition from one volume to the next inside a form, like a shoulder into an upper arm, a foreleg into an ankle, or an ankle into a foot.

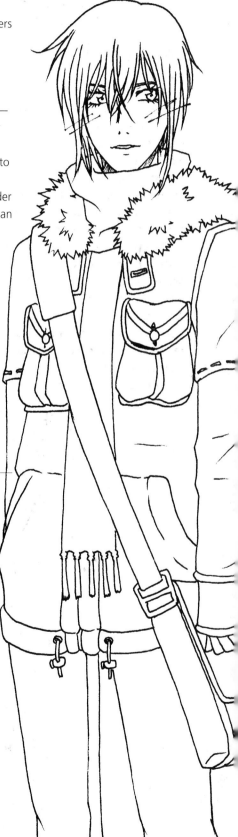

Stage 3: inking digitally (left) or by hand (right)

An inked version of the cleaned-up sketch should be clear and define all areas of the form that is to be colored. Line weight can be uniform throughout, but a more attractive drawing is made with a variation of line widths, and where the line itself varies along its length and ends in tapered points and flourishes.

Great digital manga babes: 20 tips

Your Manga Babe can be drawn on paper first and then scanned into the computer for finishing or you can draw her directly into the digital world using a graphics tablet! Remember that the computer is just another tool. However much you do use it, these tips should help at any stage of your work.

1. Using Photoshop

Photoshop is the most widely used program for digitally generating manga art. Work is done in layers, and you can keep your line work separate from color in case of mistakes. Work at a higher resolution than needed for your final product; it is better to work large, then reduce the overall size later.

2. Using a tablet

You can draw directly into the computer by sketching with a graphics tablet. This method has the advantage of layers: you can add a new layer on top of your original sketch, turn down the opacity, and redraw your image with more certainty, refining it until you're happy.

3. Scanning large artwork

Drawings that will not fit on the scanner glass can still be scanned, in two or more pieces. Try to keep your artwork edge straight on each scan. Combine the two images into one new document, and use a soft Eraser or Mask on the edge of the upper image to blend the edges together.

4. Use grayscale

When scanning your drawing, use a grayscale output mode. Grayscale will pick up fine details that the line art or black-and-white option will leave out. You can change your image into line art later.

5. Use a high resolution

Scan at the highest resolution you can. The minimum is 300dpi, but 600dpi is better. Some high-quality scanners can do 1200dpi or higher.

6. Reduce "show-through"

If there are marks on both sides of your original drawing, reduce show-through by scanning with a black card on top of the artwork.

7. Clean up your lines

You can use the Sharpen tool or Unsharp Mask filter in Photoshop to make your lines cleaner. Use the Scratch Board tool in Painter. To prepare the art for coloring, change the image mode to permit layers, to CYMK or RGB. Cut and paste your line art into a new layer, and change the layer blending options to Multiply. This will make the background colors transparent and the lines blacker.

8. Making colored lines

To make colored lines from black ones, copy your art onto a new layer, and use Contrast and Brightness to get the best crisp version of your original grayscale lines. Erase the white areas, and paint the lines with color.

9. Ink by hand, then scan

Many artists find it faster and easier to ink by hand. Print your tight pencil drawings in light-blue lines, and ink with your preferred pen. Scan the inked version back into Photoshop or Painter to finish in color.

10. Ink digitally

A good graphics tablet, such as one from the Wacom Intuos series, can produce line variation along the length of the stroke by

Flatbed scanners are used for digitizing drawings into the computer. Yours should be the highest quality possible, with an optical resolution of at least 48,000dpi and the largest glass that is practical.

responding to changing pressure on the stylus. Your tablet should be a comfortable size for your hand and drawing style.

11. Practice, practice, practice

Effective digital inking comes with practice, through control of your hand and body. It is not the tool, but the artist's control that gets the best results. When inking with a graphics tablet, use the Rotate Canvas option for turning the artwork for easier inking. Do not use the Arbitrary option, as this will damage the lines when you rotate the artwork upright again.

12. Finishing line work

Comicworks is a program designed for the production of printed manga in black and white. It is useful for finishing up line work, but no color can be applied within this program; your art will have to be exported to another program for coloring.

13. Paint under gray areas

After using the Magic Wand tool to select an area to be colored on your color level, expand your selection by one to three pixels to make sure you paint under any gray areas next to the black lines on the line art level.

14. Using the Fill tool

To select entire areas for painting, use the Fill tool with Contiguous off on grayscale outlines or with Anti-aliasing off on black and white outlines. The Fill tool requires the outline to be completely closed around the area to be painted: close gaps using the Fill color and the Brush tool on the color layer.

15. Cel-style coloring

Animation artwork generally uses a limited color range, representing mid-tones, shadows, and highlights: in manga art this is called cel-style coloring. Shadows and other changes in color are cleanly delineated. (See "Mecha pilot," page 48.)

16. Define folds and hair

The Smudge tool can be used to draw out folds of cloth or define sections of hair. Add layers of tone to hair and smudge each to create highlights. Manga hair is always very shiny!

17. Save your colors

Once you have used a color on your digital artwork, save a daub of that color on a palette layer that will not be seen in the final art, but will be there if you need that color later.

18. Imitate natural media

For a more realistic look, natural media such as watercolor can also be imitated digitally. Painter, as a program dedicated to simulating natural media, is a good choice for watercolor-style coloring: pale washes can be applied, as in real watercolor work. (See "Hip-hop girl," page 66, "Glamour girl," page 86, and "Kindergarten girl," page 96 for examples.)

The bottom layer in Painter is called the Canvas and can work like a wet layer once the Method is set to wet. There are many settings that affect the way the paint blends apart from Opacity in Painter, such as Bleed and Dryout. Play around with them until you are happy with the results.

19. Use gradients

Gradients are areas of color that show a gradual change across two or more colors. This is a simple way to fill areas with soft-edged variation. When combined with shading and subtle highlights, they can be an effective alternative to natural media. (See "Witch," page 78, and "Festival girl," page 54 for examples.)

20. Add texture

Texture can be added to colors as a separate layer in Photoshop. The program comes with many file textures, or you can make your own. You can lay the texture on top of paint and play with blending options such as "Pin Light" or "Linear Dodge" to achieve different looks.

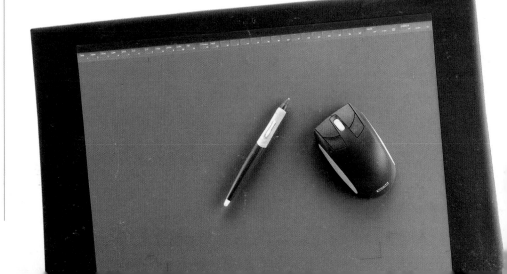

Used with both a digital pen and a mouse, a tablet makes it easy for anyone to draw on a computer. The pen features 1,024 levels of pressure sensitivity and comes with three nibs for a variety of "feels."

Choosing color palettes

While choosing an appropriate color scheme is important, there is really no exact science to the process. Experimentation and referencing works of professional artists are the best options, and you can gain much insight by scrutinizing the color schemes that others choose to use.

Most anime/manga artists tend to prefer strong, bold colors because they communicate the vibrancy of the dynamic line-art style. Primary colors (red, blue, yellow) and their complementary counterparts (opposite them on the color wheel: green, orange, purple) are often used with maximum saturation to emphasize the cartoon feel.

On the other hand, anime/ manga with a slightly serious or adult edge will often opt for a more muted color scheme, preferring tertiary colors, such as browns and grays, and generally darker muted tones.

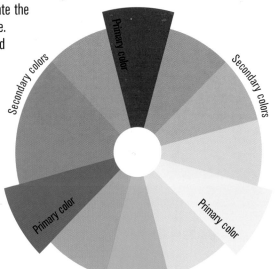

Skin tone and hair color

As individuals, we all have a slightly different skin tone. While skin color can be loosely grouped by ethnicity, within those broad categories there are countless variations, and within the fictitious realm of anime there should be no boundaries. Colors can be even more vivid than in real life, and professional anime artists often opt for skin and hair colors that are way beyond the ordinary. These examples to the right show how skin and hair tones alone can change the context of a character.

Palette: Light and vibrant

This is an example of a color scheme chosen to be vibrant. Vivid primary and secondary colors, such as reds, blues, greens, yellows, and purples, are used. Even though this seems like a lot of colors, the overall impression is harmonious. Bright colors attract the eye, and complementary colors placed together (for example yellow and purple) increase the intensity of each other. The white shirts and bright highlights in the hair break up the adjacent complementary colors, while at the same time providing a path for the eye to travel around the composition.

SKIN

EYES

HAIR

CLOTHES

- Yellowish, sandy skin tone.

- Large green eyes, cotton-candy pink hair.

- Khaki green beret and tie.

- Beige shadow tones depict a sand/cream-colored shirt.

- Pale skin tone with strong reddish hue.

- Bright green eyes to complement the intense red hair.

- Medium-navy blue clothing.

- Gray shadow tones give form to the plain white shirt.

Basic line art
The basic line art, uncolored and ready for rendering.

Pale skin
A light skin tone with minimal hue, suitable for a very pale Caucasian character. The turquoise hair matches the eyes and works in harmony with the fair skin. The red eyeshadow and lipstick are vivid.

Rich skin
A rich skin tone with a strong orange/yellow hue, suited to an East Asian look, especially when coupled with black hair and brown eyes. The makeup is arresting, with blue and orange complementing each other.

Dark skin
A darker skin tone that represents an African-American character. Here, a red-brown hue is used to give a vibrant glowing skin tone. The pink hair and makeup create a fantasy appearance.

Palette: Dark and moody

This is a darker color scheme than in the opposite palette, evoking a more serious attitude. The red and purple uniforms are not bright, resulting in dark cherry red and deep violet. These colors coupled with black accents (skull insignia!) emphasize the gloomy tone. The contrast of deep rich colors and black clothing and pale faces is arresting. The eye travels back and forth, trying to decipher the meaning in this odd relationship.

SKIN

EYES

HAIR

CLOTHES

- Very pale, colorless skin.

- Dark electric blue hair in contrast with the pale skin.

- Deep violet uniform in harmony with the blue hair (cold tones).

- Shiny black PVC collar, cuffs, and belt.

- Orange/brown tan skin.

- Strawberry blonde hair in contrast with the dark skin.

- Dark cherry red uniform in harmony with the blonde hair (warm tones).

- Shiny black PVC collar, cuffs, and belt.

Proportion and scale

The relative proportions of a body vary widely, and change throughout life. At a glance, you can tell a lot about someone simply from his or her proportions. There are some simple rules to remember when drawing your manga babe. Take the head measurement and use it as a way to design the whole form. A figure can be two or three heads tall; this describes a very young child ("chibi"). An older child might be four heads tall and an adolescent five or six. Adult characters are usually between six to eight heads tall, although superheroes or thugs may be larger!

Measuring up

Crucial proportion measurements include not only the height of the figure, but how much of that height is taken up by legs and where the waist is. In most characters (from four heads tall and upward), the legs take up half the body length. This is not realistic, but appears better balanced. Let's look at the various types of female characters in this book.

The chart below shows the relationship of head size to body size across a selection of characters. These body types show many of the conventional proportions used in manga art. "S.D." means "super-deformed," a Japanese term for exaggerated proportions that is similar to "chibi," meaning "cute."

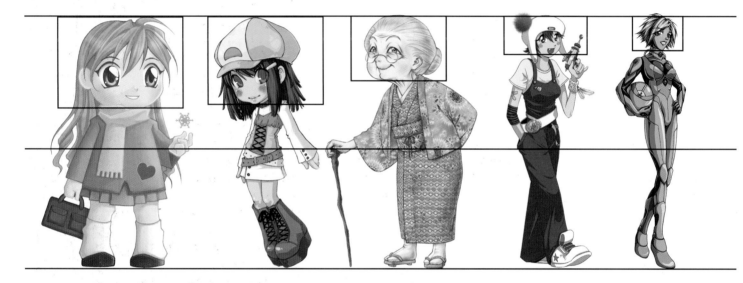

S.D. child: almost three heads tall.

S.D. youth: three heads tall.

Comic type: almost four heads tall.

Real girl: about six heads tall.

Super girl: seven heads tall.

Build your drawing from simple shapes

Always draw the underlying structure of your character first, before adding details. Pay attention to how the body parts change in relation to each other when they move. Think of your characters as being constructed of a series of cylinders (arms, legs, chest) connected by spheres (knees, elbows, shoulders).

Start with a center line, sometimes called the line of action. This should be a curve, because a figure in action should look unified and fluid, not broken up and clunky. Organize your figure's

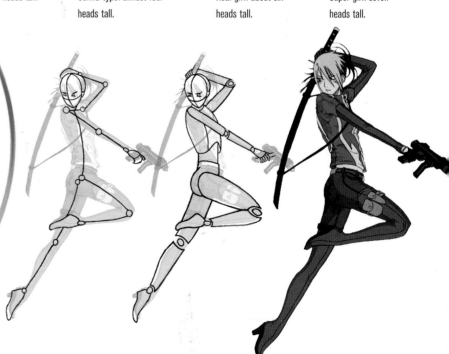

Every character is made of parts: define and move these parts and draw them from many angles to make convincing poses. Trace over these construction drawings to finish your manga babe.

torso, lower body, direction of gaze, and limbs using very simple stick-figure lines. Fill this stick figure out with simple shapes, describing the volume and shape of the head, chest, legs, and arms. Starting with a curved line of action produces the most dynamic and energetic results. Your character's silhouette is descriptive and rhythmic.

Get to know your character through posing

Once you have an idea for a character, explore by drawing the body, using those simple shapes, changing perspective, and building the details around them. This is the best way to visualize your figure at different angles and will be an essential tool for achieving effective foreshortening.

Twisting and exaggeration

An artist's representation of a character should always tell a story. Study the manga babe examples to see the most active poses. These always include some twisting, as seen in the "Assassin" (page 42), some exaggeration, as seen in the "Mecha pilot" (page 48), and often some foreshortening, as seen in the "Martial artist" (page 46).

What makes up a manga-style girl?

Although a manga female can be young or old, some characteristic features persist:

- Round or heart-shaped face
- Large eyes; wider and bigger eyes indicate a pure, young, and innocent girl
- Narrower, smaller eyes mark a wise or cunning, even evil, girl
- Long eyelashes
- Shadows on the eyes under the lashes
- Highlights in eyes; the number and variation of the lights denote how dreamy and lovely the girl is
- Chins are either rounded or pointed
- Noses are small, with nostrils rarely on show
- Lone shadows, without lines, may define the nose
- Noses are smaller (or even absent) in younger girls
- Long noses for aristocrats
- Larger, more realistic noses are seen on older women
- Mouths are usually small; they may be a dot, a short line, or even absent
- There are no lips in excited expressions; exaggerated and unnatural shapes are conventions of the style
- No individual teeth, all in one shape or one line
- Ears are rarely seen and are very simple
- Manga hairstyles reflect personalities
- Rounded and smooth shapes denote well-behaved, delicate, passive girls
- Sharp points and irregular shapes denote a dreamer or a rebel, an active girl
- Accessories are varied: ribbons, headbands, clips, tiaras, hats, and glasses
 - Classic Shoujo-style drawing approaches the Victorian ideal for women: tiny rosebud mouths, large expressive eyes, dainty noses, and beautifully coiffed hair

Foreshortening is used very successfully in the pose of the "Martial artist." This pose also tells the character's story.

Clothing and accessories

Manga babes can wear anything, but let's look at both the traditional clothing and the latest Japanese styles seen simultaneously in manga and in real life in Tokyo!

Traditional Japanese clothing and women's accessories

Traditional Japanese clothing dates back hundreds of years, yet it is still comfortable to wear and beautiful today. Not many Japanese people use this clothing in everyday life, but it is still often worn at family celebrations, holidays, and festivals. The young have even taken it up as part of their creative fashion vocabulary: the quality of "Japanese-ness" is called "wa" in their language.

Kimono A robe with full sleeves, made in fine fabrics in seasonal colors and patterns. The main part of the Japanese traditional costume, it is worn by both men and women. Women wear different kimonos depending on occasion and season; men's kimonos are shorter, made in dark colors and worn with a black silk haori jacket and loose-fitting hakama pants.

Yukata A version of the kimono made for summer wear, fashioned from light fabrics such as cotton. Yukata normally have very brightly colored designs, and are worn either with just the matching cotton sash or a wider obi belt for attending festivals and public occasions.

Obi A wide belt tied around the middle, used to hold clothing closed. It is simply wrapped around the waist and tucked in at the edge. Women and children add a large bow at the back.

Hakama Very full pleated trousers resembling a skirt, mostly worn by men and sometimes by women. A practical garment, the hakama accommodates vigorous activities like traditional sword fighting and also keeps the kimono clean at outdoor festivals.

Tabi Socks with a separated part for the big toe, needed for wearing with thong sandals. In Japan these are usually sewn from cloth, not woven as socks, though this Western form is also becoming more popular.

Zori The origin of the ubiquitous "flip-flop," or "thong" sandal: traditionally made from hard wood, they are now made of many different materials. The thong cords can be made of plastic or rope covered in cloth. In Japan, the foot beds are not flat, but rise in a slope toward the heel.

Geta Similar to the zori, but made of wood and raised on wooden blocks, called "teeth." These make a clacking sound like clogs when worn, and keep the wearer's feet dry in rainy weather.

Haori An unlined short jacket worn by men and women over a kimono. Formal dress for men includes a black silk haori. They are often worn by women in cold weather.

Handbags or purses Small handbags can be any style, but purses and small drawstring pouches made from old kimono cloth are particularly interesting.

Fans From ancient times women have used hand-held fans to cool themselves and to shield their faces from unwanted glances. There are two kinds: the flat fan ("sensu"), which was inspired by the shape of leaves or a bird's wing, and the portable foldaway sensu. The paper or silk used to make the fans can be decorated with painting, or printed patterns, thus adding the beauty of form to its practical function.

Hair decorations From an elaborate bow worn by little girls when they wear kimonos to beautifully decorated combs and hair pins worn by women on ceremonial occasions, traditional hair ornaments ("kanzashi") are all opportunities for creative adornment descended from those worn by geishas and noblewomen hundreds of years ago.

Obi jimi (see kimono illustration) A small braided cord tied on top of a woman's formal obi to keep it in place.

Han-eri The eri is a collar worn under the kimono that peeks out and gives the appearance of layering without adding another layer of clothing.

Paper parasols The traditional Japanese umbrella ("wagasa") uses only natural materials and requires the skilled hands of a dozen seasoned craft workers.

Paper lanterns A "chochin" is a portable light that traditionally uses a candle as a light source. It is made of Japanese paper applied to a spiral-shaped coil of bamboo, and rings are fitted to the top and bottom so it can be collapsed and folded flat. It was believed to protect people against evil spirits.

Fashion subcultures seen in manga

• Sweet Lolita
• Elegant Gothic Aristocrat
• Decora
• Gyaru ("gal") styles:
 Kogyaru
 Gangoro ("face-black")
 Himegyaru ("Princess gal")
 B-gyaru ("B-Gal")
• Serafuku ("sailor outfit") School Uniform
 and many others...

(Left) Japanese girls wearing "Decora"-style fashion, made up of colorful clothing that is often secondhand or handmade, and many accessories, including noisy plastic toys, cell phones, jewelry, and synthetic hair extensions.

Drawing folds and wrinkles in clothing

What your character wears plays a huge part in communicating who she is. Each of the different materials in her costume will show distinctive folds and wrinkles. Learn to draw these effectively to increase the impact of your manga babe.

Different materials show different folds

• Softer materials such as silk or velvet create larger and rounder folds than tough materials like wool and leather. A heavy trench coat will fall in sharper, stiffer folds.
• Folds point toward the center of tension where the material is strained, like at a shoulder or a knee.
• Study folds in a piece of cloth hanging from a single point: the folds are narrow near the top and fall away into wider waves at the bottom.

Ask these questions about your character's costume:
• Is each piece worn long or short when standing?
• Does it hit the ground?
• Is the material thick or thin? Light or heavy?
• Does the fabric lie loosely or tightly around the figure?
• What parts of the figure are pushing or pulling on the costume?
• Are those parts of the figure bony or fleshy?

(Far left) The blue check shirt forms soft folds on the arm. (Left) Thick and heavy leather forms distinct folds. (Above left) Light fabric falls from two points to billow up in waves. (Above right) See the rounded edges and gradual changes over the surface of the soft jersey. The stiffer pants form sharper creases along the leg and larger folds where they settle. Notice how many folds spread out around the hand in the pocket, where it strains the material.

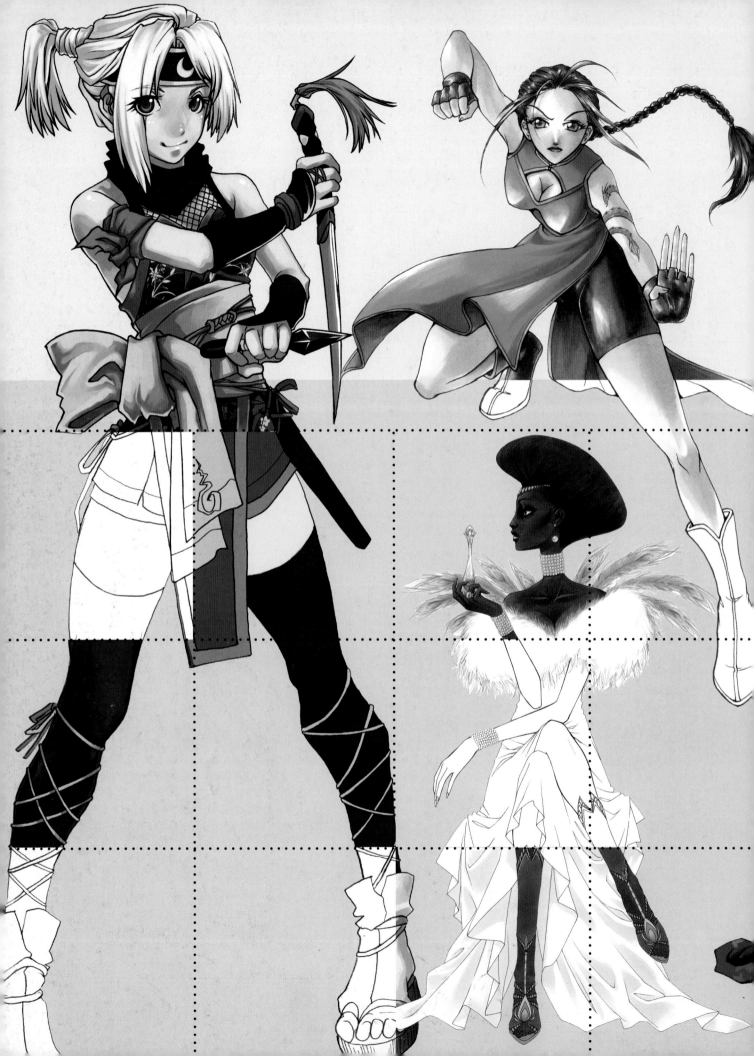

CHAPTER 2
The cast

This chapter demonstrates how to draw and paint 50 manga babes, from manga fan favorites to fantasy femmes and warrior women, and from girls next door to "supercute" or chibi-style characters. For each design, there are character details, color palette tips, and head rotations as well as line art and color and shading instructions. You will be taught to build each character individually and will discover techniques to carry into any project. Pick your favorites or explore new designs of your own.

School girl

See also

*Great digital manga babes:
20 tips, page 20
Clothing and accessories,
page 26*

Meet Miu

Too much homework, overbearing teachers, having no boyfriend, etcetera, etcetera... Miu is your typical high school student, with your typical high school problems. But despite being touted as an illustrious academic with a bright future, all Miu really wants to do is to draw. Her real passion in life is manga comic illustration, and she loves nothing more than telling great stories with beautiful, diaphanous line art. Of course this is something she keeps to herself, because those close to her would never understand why she would throw away her education just to doodle! Despite this Miu persists, and is busy after school every day, working on her next manga. Maybe it's time for Miu to show the world what her vivid imagination, and drawing skills, are capable of! Go Miu!

Character Details

Hair: An unconventional shade of blue in girlish pigtails.
Clothes: The ever-popular sailor school girl outfit!
Accessories: Decorative blue ribbons on the socks.
Details: Classic black leather high-heeled school shoes.

ABOUT THE COLOR PALETTE

The pure white of the socks and shirt provide counterpoint to the deep blue of the uniform skirt and collar. A red tie adds excitement to the limited palette, and is picked up in the cheeks, lips, and hair fastener color. The blue hair also works against the conventional color choices.

Tips on this style

Because so many animes and mangas are based in high school, the sailor school uniform is rather ubiquitous. Many manga artists use different color schemes, and elaborate on specific parts of the uniform, in order to keep it fresh. This example uses the traditional scheme of navy blue and white, with the uniform as close to its original form as possible. Before making your own embellishments, it's wise to get the basics down first.

Character studies

Miu still has some childlike qualities. Her side-fastened pigtails are typical of the hairstyles at school. She looks at the world with curious eyes from a pink and white complexion.

Artist's shortcut

Scan or trace this:

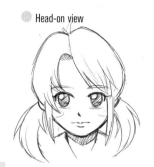

● Head-on view

Miu looks up through her lashes as her hair blows about her round face.

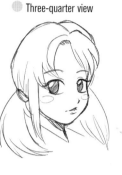

● Three-quarter view

A more relaxed pose as her face is slightly turned away and her pigtails brush her shoulders.

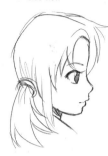

● Side view

Her nose and mouth are small, her expression is serious.

DEMO: SHINY SHOES

Step 1: To start, fill in the shoe area with black. The outline will disappear. To remedy this, turn the opacity of the black layer to 50 percent.

Step 2: The original outline is clear. Highlight the shoes on a new layer (no need for shading, because it is black). Use a big, soft brush to articulate every curve.

Step 3: Go back to the original black layer, and turn the opacity back up to 100 percent. Make the shoes appear even shinier by adding patches of white.

1. Line art

Understand how the outfit works; first the shirt, then the skirt, lastly the sailor bib over the top with a ribbon tying it together. Refer to the sketches for more detail.

2. Adding color

Simple really. To get the best balance, refer here: white shirt and socks, blue bib and skirt, finish off with a red ribbon and black shoes. The turquoise-blue hair gives Miu a very exciting, bubblegum look.

3. Adding shading

Effective shading accentuates the creases in the clothing, but is harder than it looks to get right. As with any figurative render, it is crucial to understand how fabric rests on the body. Study-real life photographs, and pay attention to how different fabrics fold and bunch. The more you understand, the more convincing your render will look.

002 Princess

See also

Watercolors,
page 16
Combining media,
page 17

Introducing Princess Ingrid of Sweden

With her light blonde hair, blue eyes, and delicate looks, Ingrid is the very picture of
Scandinavian beauty, and along with her gracious demeanor this has earned her many admirers.
She loves to dance and is greatly inspired by the waltzes of Johann Strauss and Tchaikovsky.
She is also a superb harpsichord player and practices her craft daily.

Character details

Hair: Long, with plenty of soft curls to frame the face.
Skin tones: Like a fragile porcelain doll, she has pale skin and rosy cheeks.
Accessories: Elegance is of the utmost importance, and small, understated
pieces of jewelry, dainty ballet shoes, long white gloves, and a small
folding fan capture this beautifully.
Color scheme: Blue is a color traditionally associated with nobility
and status, while pale skin, blue eyes, and blonde hair are typical
of a classic romantic heroine.
Details: To create a dreamy, doll-like appearance, the eyes and lips are
glossy and the dress is trimmed with lace and decorated with bows,
jewels, and fine embroidery.

Tips on this style

Ingrid has been drawn in the shoujo (girls) style that was popular
in manga in the 1970s and, although less common, still retains a
following today. It's a classic, romantic look characterized by
delicate features, large eyes, and soft lips.

ABOUT THE COLOR PALETTE

Blue and purple were rare and
precious colors in ancient times.
Wearing textiles tinted with these
colors was a sign of royalty and
status, and even now they can project
these ideals when used correctly. Use
silver instead of gold for jewelry and
ornaments to complement blue
clothing and avoid clashing with
blonde hair.

Character studies

Elegance and delicacy are vital to the shoujo style. It's important to make sure that the proportions, as well as the hairstyle and jewelry details, are consistent. Character studies help you to become familiar with these details.

⬤ Head-on view

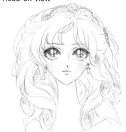

Hint at the lips using small lines and curves.

⬤ Three-quarter view

Angular shading around the eyebrows and nose emphasizes the fine facial features.

⬤ Side view

Making some details overlong, like the neck and nose, enhances the impression of nobility.

Artist's shortcut

Scan or trace this:

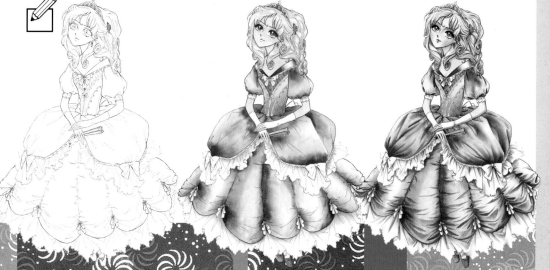

DEMO: FEATURES

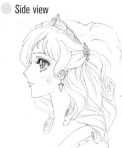

Step 1: Apply the ink along the lines of the hair, almost to the points that will remain white. Wash the ink out of the brush and dab it dry, then blur the edges.

Step 2: Use a thin brush to add depth of color to the hair. For rosy cheeks, moisten the paper and apply colored ink to the center, then blur with a clean, damp brush.

Step 3: The star-shaped sparkle in the eyes is characteristic of shoujo. Add a dab of opaque white ink to make the lips fuller and glossier.

1. Line art

The style is elegant and intricately detailed, so don't rush the sketch. Use a black ballpoint pen to draw the sketch on watercolor paper—its rough surface will make the ballpoint pen lines appear even finer than fine liner pens.

2. Adding color

Before coloring, plunge the paper into water until it is completely saturated—don't worry about the sketch, as ballpoint ink is waterproof. Watercolor paper becomes stretchy when soaked in water, so stretch it out on a board and tape the corners down to prevent it shrinking as it dries. The tension this will create in the paper will prevent it from rippling during painting. Use watercolors or colored Indian ink to create a shimmering effect, and finish off the silver details using opaque gouache paint.

3. Adding shading

Use colored Indian ink to add the shading. Indian ink is ideal for creating smooth gradients of color—its colors are brighter than watercolor paint and it's waterproof when dry, so several layers of color can easily be applied to the same area. Finish off by using opaque white ink to make the eyes bright and the lips glossy, and to add fine embroidered details and glittering ornaments to the dress.

003 French maid

Belle says bonjour!

Belle works as a maid in a gorgeous baroque-style mansion in Fleurville. Although her bedroom is in the attic, she's content because it affords her a beautiful view of the mansion gardens. She is attentive and quick to attend to her employers or their guests when they need something. She is a diligent employee and likes to carry out all her tasks properly.

Character details

Hair: Short and slightly tousled to capture a sense of both quiet sophistication and a fun, carefree nature.

Skin tones: Pale, with a light hint of pink blush on the cheeks to make her look both alluring and innocent at the same time.

Accessories: The small, white frilly cap and gloves are typical accessories for a French maid's uniform, and the look is given extra appeal by the stockings and garter belt. Her choker enhances her slim neck, making it appear longer. Finally, no good maid would ever be seen without a feather duster.

Color scheme: Monochrome colors can be too sharp for a sweet girl like Belle. Depth and a sense of luxury are added by coloring the dress very dark purple instead of black, while the white garments are tinted with rosy pink for warmth.

Details: A delicate lace trim is essential on every part of the uniform apart from the dress skirt. Because she'll be on her feet all day, her shoes need to be practical but cute. Patent leather kitten heels are ideal.

ABOUT THE COLOR PALETTE

Although purple is an important color, shades of pink are vital. Choose a warm apricot tone rather than baby pink as this can make the palette appear too cool. Add a touch of green for contrast to give the image a fresh look.

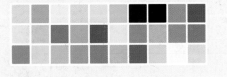

Tips on this style

With its black dress and white apron, the typical "French maid" costume is a stylized version of a 19th-century maid's afternoon uniform and is all about looking seductive. The waistline is cinched in and the skirt is short but wide, supported by a white underskirt to give it shape.

Character studies

A balance between innocence and appeal is important here. Remember to keep the eyes big and round and the neck long and slender.

Head-on view

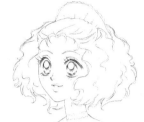

Three-quarter view

Side view

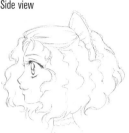

The body-wave hairstyle has a very chic, French quality to it and frames the face beautifully. The facial expression is bright and curious.

Be sure to keep the proportions consistent and make sure the cap isn't too far back or forward.

Be aware of the head shape when drawing the hair–this is a voluminous hairstyle! Slightly pouting lips add a seductive touch.

Artist's shortcut

Scan or trace this:

DEMO: SKIN TONES

Step 1: Don't simply use darker shades of the base color to add shading—subtle shades of red and blue will create an interesting look.

Step 2: To create depth, use another, darker color and apply it to the shaded portions using the Gradient coloring tool.

Step 3: Finish by blurring the outlines slightly to create the effect of warmth and make the artwork look less sterile.

1. Line art

Once you've made your sketch, use a lightbox to trace it onto a sheet of smooth color copy paper. Use a pen with a 0.10 nib—this is the thinnest fine liner you'll ever see! Make sure to take your time to draw clean lines and avoid a sloppy-looking finish.

2. Adding color

Scan the traced outlines and add base colors using an art program like Micrografx Picture Publisher. This is where good line work pays off; ensuring all the outlines are closed (with no breaks), so that the color doesn't bleed out when using the Paint Bucket tool means a lot of time is spared at the coloring stage.

3. Adding shading

Shading can also be applied using Picture Publisher. Draw the outlines of the shaded areas with a brush in the same thickness size as the black outlines, so the edges of the shadows don't look thicker than the rest. Then use the Paint Bucket tool to fill in the shading colors.

004 Catgirl

Nerumi says nyaa!

Once an adept thief and spy for her tribe of cat people, Nerumi ran into trouble when she was captured during one of her "outings," and an evil witch doctor put an old bell curse on her. Now she's unable to slink around undetected as she once did, but she's still very quick and agile, and can be an extremely vicious opponent. At heart, though, she's as playful and mischievous as a kitten.

Character details

Hair: Nerumi's hair parts on either side of her head to accommodate her ears, and it's been tied into bunches at the front.
Skin tones: Warm, tanned skin tones.
Accessories: The large, golden bell around her neck serves as a reminder of her curse.
Color scheme: Nerumi is a tabby cat at heart so her color scheme draws on the tabby coat pattern, with various shades of orange and beige, and black stripes.
Details: Her clothes are tight-fitting for ease of movement, but not too revealing. Don't forget the tiny fang in one corner of her mouth.

ABOUT THE COLOR PALETTE

Nerumi's colors are based on those of a typical, cartoonlike tabby cat. The shades of orange and brown match her mischievous personality. Meanwhile, the blue used for her hair adds contrast and depth to the color palette.

Tips on this style

There are several different ways you can draw a catgirl. Nerumi is a good example of a fairly simple catgirl, having large ears and a tail but otherwise appearing human. More complicated variations can include large paws on the hands and feet, long claws, and appropriately placed patches of fur in place of clothes. If you feel especially ambitious you can try drawing a catlike face too, but this kind of catgirl is rare.

Character studies

Although there are exceptions, catgirls tend to be caught between being cute and sexy. Nerumi is right in the middle—she has a cute face but there's a dishonest quality to her look, and her active lifestyle is reflected in her lean figure.

Artist's shortcut
Scan or trace this:

Head-on view

Large, rounded eyes create an innocent look, but the slightly sharp outline of her face and longer features make her seem a little more mature.

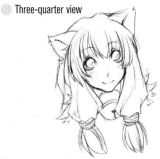

Three-quarter view

Work out exactly where her ears are on her head and part her hair around them.

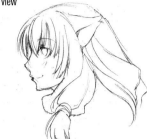

Side view

Make sure to keep the position of her ears and the way her hair falls around them consistent.

1. Line art

Nerumi is athletic, which means that sketching her figure is a little more complex than usual. Make sure not to make her too muscular or voluptuous. Once you're happy with the sketch, trace it on a lightbox, scan it, and clean it up digitally. Clothing details aren't necessary at this stage.

2. Adding color

Block in the mid-tone, base colors in preparation for shading using the Magic Wand tool.

3. Adding shading

Establish a light source and add shading and highlights as appropriate. Use a combination of sharp and soft-ended painting tools. Finish off by adding clothing details, such as the zipper, and the buttons on her boots.

DEMO: FUR

Step 1: Block in mid-tone color using the Magic Wand tool.

Step 2: Apply a darker shade with the Pen tool, taking into account the direction and shape of the fur as well as the light source.

Step 3: Finish off with a few light-colored flecks to add depth to the fur and indicate the light source.

005 Ninja

See also

*Great digital manga babes:
20 tips*, page 20
Clothing and accessories,
page 26

Tricky Tsubame

Tsubame is a strong young woman who was born out of wedlock to an incredibly talented and beautiful female ninja. Now a vagabond ninja herself, she has trained hard to hone her skills in the hope that one day her mother—who still plots revenge against the man who never took her love seriously—may be at peace.

Character details

Hair: A cool silver-gray color, tied back to keep it out of her eyes.
Skin tones: Quite warm and dark—any ninja who trains regularly outdoors should have tanned skin!
Accessories: Ninja weapons are essential—kunais and wakizashi (Japanese short swords) are two examples. Sheaths for these weapons should be held in place with thin, ropelike belts.
Color scheme: A dark and moody palette—black, gray, and silver with some red and purple for variety.
Details: The main part of the costume is like a heavily stylized yukata (a summer kimono)—it has no sleeves or shoulders and is cut quite high on her legs. The large obi (sash) is the only indicator of what the outfit may have originally looked like.

Tips on this style

Ninja were active in Japan until the late 19th century. When drawing a character like Tsubame, it is important to understand the clothing of the time, while giving the design a contemporary look. The clothes should not be heavy or cumbersome—ninja need to be able to move freely.

ABOUT THE COLOR PALETTE

Two key things to remember about ninja are that they mostly work at night, and they must be able to blend with their surroundings as much as possible. As such, a "nighttime" color palette is the best one to use—dark colors like black and purple with lighter shades of gray and silver to give it some variety.

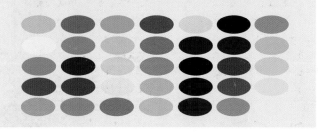

Character studies

Since she's an outcast, there's a lot of flexibility to Tsubame. There's no set uniform to follow so the emphasis is on making her look cool, while still being reminiscent of historical Japan.

● Head-on view

A confident face, bright but hinting at a darker side to her personality.

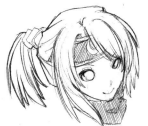

● Three-quarter view

One of her bangs is longer than the other to give her a more interesting appearance. Be careful about keeping the length consistent.

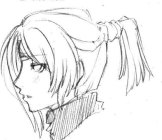

● Side view

A sharp, mature profile with slightly closed eyes to present an air of mystery.

Artist's shortcut

Scan or trace this:

1. Line art

The design is made complicated by both the clothing details and the many accessories she is carrying. Decide which details you want to include before you start; then, when you have a base sketch, trace a clean image using a lightbox. Once you've scanned the image, clean the lines up further on the computer.

2. Adding color

Neatly block in your base colors. Use a separate layer for each different part of the sketch—it'll make things much easier once you start shading!

3. Adding shading

Once the base color has been applied, put a transparency lock on your base layers before adding shading and highlights. Use the Eyedropper tool to find different shades of your color choices, and smooth out the edges between different shades using the Airbrush tool. Add extra details like clothing patterns once the shading is finished.

DEMO: TEXTILE PATTERN

Step 1: Block in the base colors.

Step 2: Make sure you blend the light and dark shades well to create a "painted" finish.

Step 3: Add clothing details using a patterned Brush tool—small flowers, particularly cherry blossoms, are a good choice for characters like Tsubame. Layer different colors on top of each other.

Swordswoman

See also

Creating great line art, page 18
Great digital manga babes: 20 tips, page 20

Laetitia says en guard!

The daughter of a once world-renowned French swordsman, Laetitia has devoted her entire life to the art form for which her father was so revered. In her early teens, Laetitia witnessed her father's fatal defeat at the hand of a master samurai from Japan. She has vowed to one day be good enough to exact revenge by defeating her father's killer. Since then she has toiled day and night, studying all the different forms of swordsmanship, and honing her skill to perfection. Will she defeat the master samurai from the East? Or will she suffer her father's fate?

Character details

Hair: Intricate, tied-back hairstyle, with pink rose hairband and sticks.
Clothes: Marching-band-style jacket with high collar and chest cutaway. Lacy black and white undergarment.
Accessories: Loose, fat belt. Detailed gold Art Nouveau-style sword hand guard. High leather boots with fastened straps.

Tips on this style

Laetitia is one classy lady, with a vaguely French, aristocratic look: very elegant and poised. This was achieved by the fashion and hairstyle, and further accentuated by the character's posture. Laetitia has a calm, solemn-looking face, which really helps to complete the effect.

ABOUT THE COLOR PALETTE

Red dominates, with black at top and bottom. Bright white takes over at the center, and horizontal bands of lace curve around the body provocatively. The gold belt and silver boot buckles complete the stripe motif. Gold accents the jacket, hair, and sword handle. Her hair is neatly tied and decorated.

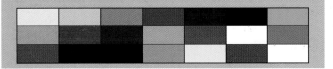

Character studies

Laetitia's hair is bound up into a precisely shaped bun and fastened with sticks. Her expression is calm and controlled.

Artist's shortcut

Scan or trace this:

Head-on view

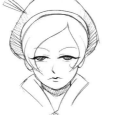

Laetitia's brooding eyes divide her face at its horizontal center or just below it.

Three-quarter view

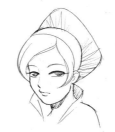

The shape of her hairdo is seen here, her facial expression more alert.

Side view

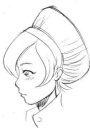

Looking glum once more and revealing a small nose and a firm mouth and chin.

1. Line art

A lot of effort should go into the line art stage of this character in order to effectively convey the baroque look. To maintain softness in the line art, very thin, delicate lines were used to create curvy contours, avoiding anything straight and hard-edged.

2. Adding color

The color palette is simple, employing mainly reds and blacks to contrast with her light skin. Yellow trims are laced onto the deep red attire, providing a striking, warm feel.

3. Adding shading

Closer inspection reveals that there are not just the usual one or two layers of shading applied to this character, nor a soft airbrush effect. Rather, a true gradual shading process has been lavished on a single layer, with the use of a hard brush with low opacity, achieving a more organic "felt tip" result, somewhere in between soft shading and cel-shading.

DEMO: LACE DETAIL

Step 1: Use a lacy pattern (a royalty-free image or a scan), and fix the color until it is black on a light background (use Hue and Saturation or Invert in Photoshop).

Step 2: With the Lasso tool cut out a strip, then paste it onto a separate layer and position it. Delete the previous layer to avoid cluttering.

Step 3: Using the Warp tool manipulate the onscreen mesh until it is in the correct position. Once in place, invert the layer and adjust the level until you can no longer see the background.

007 Assassin

See also

Creating great line art, page 18
Great digital manga babes: 20 tips, page 20

Meet Leighlah

Due to trouble at home, Leighlah moved to live with her uncle when she was six years old. There she learned various martial arts, and how to use the samurai katana. At fifteen years of age, she came home from school to find her uncle dead, assassinated. Broken-hearted, she lived with a foster family for three more years, training herself in the art of killing every day after school. At twenty four, she finally avenged her uncle's murder. Now twenty nine, she is one of the world's top assassins.

Character details

Hair: Shades of light blue and navy blue, shorter at the front and longer at the back, tied into a ponytail.

Skin tones: She is a night owl by choice, but of course assassins must generally work at night, so she has the pale skin of someone who doesn't see the sun too much.

Accessories: The essential accessory for an assassin is a weapon, so Leighlah always carries her samurai sword and a semi-automatic firearm.

Color scheme: Mostly dark tones, but with flashes of bright color in her green jacket, with yellow and red flames.

Details: Leighlah needs practical and hard-wearing clothes so she has brown leather gloves and thigh-length, high-heeled brown leather boots with blue denim jeans.

ABOUT THE COLOR PALETTE

Limbs and weapons extend out from her in dark tones of chocolate brown, black, gray, and deep blue. Those close values frame the intense red, yellow, and green of her flame-painted jacket. Her light skin is exposed only at her waist and face, which is framed by jagged blue hair.

Character studies

The character has lighter hair at the front and darker hair tied up into a ponytail at the back. She does not have much facial expression because of who she is, and the tragic history that has made her what she is.

● Head-on view

Her expression is hard and impenetrable because of her troubled past.

● Three-quarter view

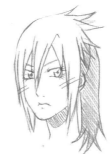

Concentrate on getting the jagged spikes of her hair in the correct position.

● Side view

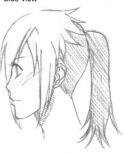

Her dark ponytail falls down her back in the side view.

Artist's shortcut

Scan or trace this:

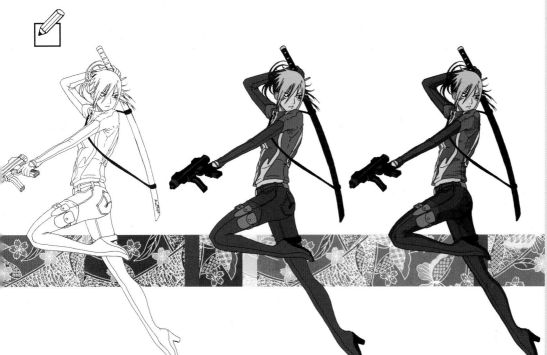

DEMO: FABRIC FOLDS

Step 1: Scan in your work as a black-and-white file into Photoshop. Change it into a color file.

Step 2: Fill in the basic color, and decide where the light source will come from.

Step 3: Using the Brush tool draw out the shades. Adding in a third shade will create a more three-dimensional look.

1. Line art

Inked by hand, the lines' width remains constant. However, giving more width to some areas will highlight them. For beginners, it is best to keep the lines the same width, until familiarity with which areas should be heavier than others is achieved.

2. Adding color

Select the areas you want to color by using the Magic Wand tool. Then color the selected areas using the Fill Bucket in Photoshop.

3. Adding shading

The shading is drawn in with the Brush tool to allow better control over the shading process than that achieved for the coloring process.

008 **Warrior**

See also

*Great digital manga babes:
20 tips,* page 20
Clothing and accessories,
page 26

Watch out for Fionnula!

A simple farm girl, Fionnula lost everything when her home was raided by bandits. Afterward, she roamed the dusty country roads, until she was picked up by a kindhearted old mercenary. Driven by the urge for vengeance, Fionnula begged to learn the art of war. Although reluctant to lead this strong-willed girl into his deadly way of life, he was persuaded, and in time he became proud of his apprentice. Woe to those who underestimate Fionnula, for she commands strength not evident in her delicate build!

Character details

Color scheme: Earthy but bright colors add a rustic, historical feel, while also reflecting her lively character.
Hair: Sunny blonde, cropped to the shoulders for easy management.
Skin tones: A nice tan and rosy cheeks hint of a life frequently spent outdoors.
Accessories: Attention is given to create a historical outfit, and weaponry.

Tips on this style

When drawing fantasy characters, it is useful to use historical references. Feel free to mix and match and tweak outfits from different time periods; no one can tell you what is right or wrong in a world you created! This is a Western fantasy character, so inspiration was taken from ancient Roman and medieval outfits.

ABOUT THE COLOR PALETTE

Muted earthy colors are appropriate for historically based fantasy characters, because they reflect natural materials and dyes. Although many of the base colors are similar, it is evident in the final result that the shading creates the impression of different materials, skin, and hair.

Character studies

Large eyes, set low, dominate Fionnula's face. The tiny nose and mouth indicate a young girl. The face is heart-shaped, but obscured by a mass of unruly hair that is drawn back with a flower, an unexpected sign of femininity. Her delicate eyebrows point down in a frown; and she has a wary expression.

● Head-on view

Slanted eyebrows show determination.

● Three-quarter view

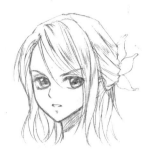

A flower adds an interesting detail.

● Side view

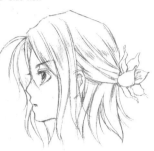

Loose, straggly strands hint at unkempt hair.

Artist's shortcut

Scan or trace this:

Line art

The line art was drawn in OpenCanvas, on a transparent layer above a scanned pencil sketch. The Straight Line tool was used for the sword.

Adding color

At this point there is little visible difference between the hair, skin, top, and tights. This is not a problem because shadow colors will add the required definition. Most colors should have their own layers.

Adding shading

The OpenCanvas Pen/Pencil tool is used for most of the shading, either directly on top of the base color or on a multiply layer. After picking the darkest shade, and applying a low opacity stroke, the Eye Dropper tool can be used repeatedly to pick up intermediate tones, creating smooth gradients.

DEMO: METAL

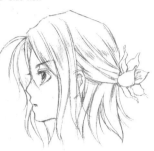

Step 1: When coloring metals remember the direction of your light source and establish the weak gradients first.

Step 2: In the area of a weaker gradient, create a darker gradient. Make sure the darker edge faces the light.

Step 3: Add reflective highlights.

009 Martial artist

See also

Marker rendering,
page 15
Combining media,
page 17

Take guard with Ying

Her name means "Eagle," and like her namesake she is agile, ferocious, and powerful. Ying is a determined Chinese warrior, who wants to be a world champion. She travels to distant shores with one thing in mind: to claim victory in battle. Aggressive and guarded, she is hard to get close to. She only shows her feelings in the heat of battle, and she relishes the idea of challenging top fighters. She fights bare-handed, believing this to be the purest, truest form of fighting.

ABOUT THE COLOR PALETTE

Choose a wide color mix; light shades are essential for blending with markers. Aim to have at least two or three shade levels for each color. Don't forget that you can use the white paper for your brightest highlights.

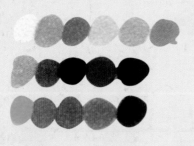

Character details

Hair: She keeps it in a long braid that she uses as a weapon, whipping it around when a rival least expects it!

Clothes: She wears a variation of "Cheongsam" (Chinese dress): sleeveless, with high slits in the side for added mobility, with modest, tight shorts.

Accessories: Practical fingerless gloves and boots.

Details: Notice the dragon tattoo trailing around her left bicep.

Character studies

Ying's heart-shaped face has wide-set eyes and a long nose. Although her hair is in a braid, some strands wave about her head, and her small mouth is set in a determined scowl as she moves into battle.

● Head-on view

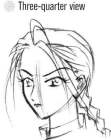

Work on the tilt of her eyebrows –she is aggressive!

● Three-quarter view

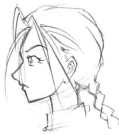

Remember to portray her braid effectively.

● Side view

Think about how the strands of hair look at other angles.

Artist's shortcut
Scan or trace this:

1. Line art

Pencil Ying on paper using 0.5 mechanical pencils. While working ensure that detail is clear and sharp. She is inked with 0.05 and 0.1 fine liners, in black, with subtle line weight variations. As this is a natural media piece using Copic Markers, ensure inks are marker-proof. Take care to erase all pencil marks to avoid smudging.

2. Adding color

When using a wide mix of soft blends and hard shading with markers, coloring and shading should occur one element at a time. Avoid laying the base colors down in one go, then applying all shading on top. Markers dry quickly, so if you need to blend while the colors are wet, do so. Start with the skin tone, or any other part of the picture with comparatively light colors.

3. Adding shading

For clearly defined edges, color in a section and let it dry. Color on top with a slightly darker shade. For blends, use a combination of light then dark, or dark then light, while the ink is wet. Be careful not to go over the edges of your line art.

DEMO: HAIR

Step 1: When trying to create any blends with markers or watercolors, work from dark to light. Always leave generous amounts of white paper uncolored—remember, you can always add color later, but once it is down you cannot erase it!

Step 2: Use very light, feathery strokes, to give the hair a strandlike texture.

Step 3: Add lighter browns on top.

010 Mecha pilot

See also

Creating great line art, page 18
Great digital manga babes: 20 tips, page 20

To the skies with Tatiana!

This is one smart lady. Tatiana is the head pilot and instructor for the Earth Defense Force, Lightning Brigade, Mecha Units. She is loud and brassy, but friendly, laid-back, and approachable–always ready to relax with her team, challenge them to arm-wrestling competitions, and drink them under the table. But when she flies she is a deadly force to be reckoned with. With years of experience, there are few who can stand up to her on the battlefield.

Character details

Hair: She has a short, spiky hairdo; long hair gets in the way of her helmet.
Clothes: She wears a full-body plug suit with removable helmet, providing maximum protection.
Details: Notice the control receptor gems at her throat, chest, and limbs, which help her to control her robots and issue commands to her comrades.

ABOUT THE COLOR PALETTE

A good distribution of three or four shades per color is needed when coloring in a cel-art style; it is a crisp aesthetic used in animation. Sci-fi and fantasy colors are used: dark skin, with pale hair and shiny fabrics.

Character studies

Tatiana's big smile sits between her delicate pointed chin and upturned nose. Lots of shaggy short hair frames her face with its big laughing eyes.

Head-on view

Get those half-lidded, lazy-looking eyes correct.

Three-quarter view

Think of the hair as spiky blocks.

Side view

Make her smile nice and wide.

Artist's shortcut

Scan or trace this:

1. Line art

Pencil Tatiana on paper using 0.5 mechanical pencils, ensuring detail is clear and sharp. Ink her with 0.05 and 0.1 fine liners in black. The resulting subtle line weight variation looks particularly good when using flat or cel-art style coloring, because this adds a more three-dimensional feel. Scan the inked drawing, and clean it up in Photoshop.

2. Adding color

Keep your line art on a separate layer, and set it to multiply. Work on a base color layer underneath. Lay out all your colors, and adjust them to ensure they work well together. A subtle tint may make a considerable difference. Keep the color opacity flat and the edges sharp.

3. Adding shading

Cel-art style shading does not use any fades or blurs—it must look crisp, clean, and bright. Use a wide range of shading levels to ensure your picture is not flat. Do not rush; neatness, precision, sharp ends, and smooth curves will make it look professional. Block out areas of light and shadow. Add contrasting lighting in increments.

DEMO: PLUG SUIT

Step 1: Getting the hang of cel-art shading takes practice, particularly when dealing with shiny surfaces. Start with your base colors, filled in flatly and evenly.

Step 2: Add in the first level of shading. Think about back-lit areas.

Step 3: Add more complex shadows and highlights.

Military

See also

Creating great line art, page 18
Great digital manga babes: 20 tips, page 20

Meet Shi-Yue Wu

Shi-Yue is a young, and inexperienced, captain. She would rather fight alone than with others by her side. The interplanetary war started ten years before she was born, and the government picked her out before birth. Since the age of three she has been educated in history and battle skills. Shi-Yue showed great promise, and by her early teens was fighting on the battlefield. Stubborn and passionate, she still manages to keep a positive attitude, even if things turn sour.

Character details

Hair: Dark violet and very straight and shiny; always kept smart and sensible.

Skin tones: Quite pale but with a healthy glow.

Accessories: Deep red beret-style cap, jacket with purple cuffs, and purple boots.

Color scheme: Dark, rich shades of red and purple, with bright gold military-style trimming. Plain gray for the trousers.

Details: Brass buttons give her jacket a military look, and her fingerless gloves hint at the need for practical and hard-wearing clothing.

ABOUT THE COLOR PALETTE

Earthy red tones suggest stability and permanence, and the golden yellow trim and buttons denote honor and loyalty, all desirable attributes for a military girl. The purple trim and boots might belong to a royal person, while the gray trousers are ready for hard use.

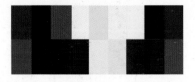

Character studies

By giving the character different facial features at different angles, she will take on life and personality. Pay attention to the different configurations her features will take with each mood.

Artist's shortcut

Scan or trace this:

○ Head-on view

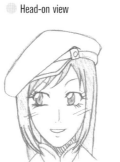

Relaxed and cheerful: her eyes gaze to the side and her mouth is relaxed.

○ Three-quarter view

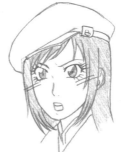

Angry and aggressive: her eyes are narrowed and mouth pouting.

○ Side view

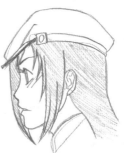

Concentrated: her profile has an intense look.

DEMO: FEATURES

Step 1: Take particular care to get the expression correct when drawing line art for the face.

Step 2: Fill in the basic color of the hair and face, and decide where the light source is to come from.

Step 3: Using the Brush tool, add the shading. Give the skin some glowing highlights. Add lighter streaks to the hair and add some color to the lips.

1. Line art

Scan the line art into Photoshop as a black-and-white file and then change it into a color file.

2. Adding color

Select the different areas you want to color by using the Magic Wand tool and then color the selected area using the Fill Bucket on Photoshop.

3. Adding shading

The shading is added with the Brush tool. Remember that every surface casts shadows. This style creates the traditional CG look.

012 Geisha

See also

Great digital manga babes: 20 tips, page 20
Clothing and accessories, page 26

Greetings from Oruha the Geisha

Oruha is a woman of many contradictions–refined yet girlish, seductive yet untouchable. She is a geisha of geiko rank in the Kyoto hanamachi: experienced and professional. The most charming woman you will ever meet, she has an air of mystery around her–who knows how she really feels? She is an entertainer and confidante, paid for her unrivaled good company! She is a master of dance, and keeps her fan with her at all times so she can perform should a client request it. Here, it is the end of a long day of formal engagements, and she relaxes with a regular client.

Character details

Hair: Long and black, artfully arranged into a traditional hairstyle, accented with pins and combs, from which a few strands have fallen free.
Clothes: As a qualified geisha, her kimono's color is more subdued than an apprentice's (maiko), and she also wears a formal "kurotomesode" (black with long sleeves) kimono, with a red and white undergarment.
Accessories: She holds her favorite fan.
Details: She wears tabi socks to go with her traditional zori sandals.

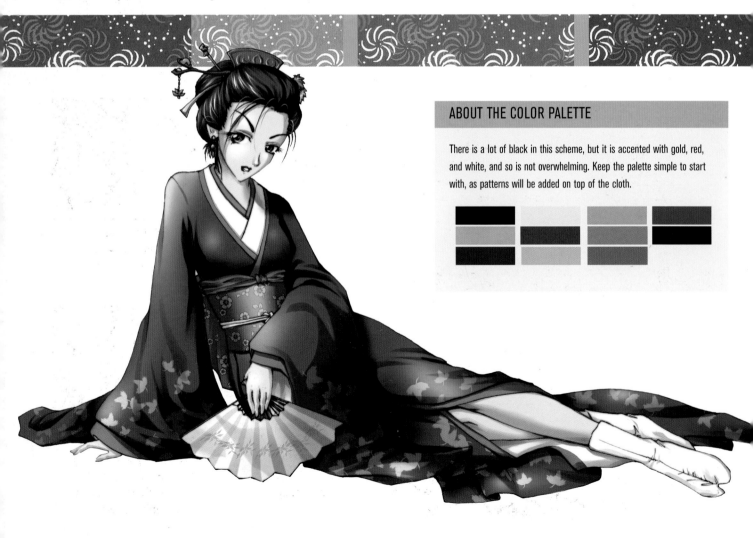

ABOUT THE COLOR PALETTE

There is a lot of black in this scheme, but it is accented with gold, red, and white, and so is not overwhelming. Keep the palette simple to start with, as patterns will be added on top of the cloth.

Character studies

This manga-style geisha has a slightly disarranged hairstyle, which would never be acceptable in real life. Her elaborate hair ornaments are called "kanzashi," and should be carefully positioned on her head.

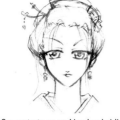
● Head-on view

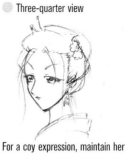
● Three-quarter view

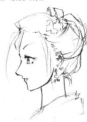
● Side view

Concentrate on making her hairline look realistic.

For a coy expression, maintain her heavy-lidded eyes.

Do not forget the accessories in her hair at all angles.

Artist's shortcut

Scan or trace this:

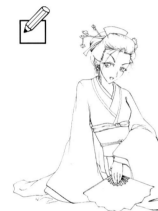

1. Line art

Pencil Oruha on paper using 0.5 mechanical pencils and ensure that all details are clear and sharp. Then ink her with a 0.05 fine liner in black ink, using very thin, light, feathery strokes. Scan the image in, and clean it up by adjusting the levels. Convert the line art into a transparent layer, and erase the white by selecting the black-and-white layer—loading all channels as a selection—and then deleting. Set the line art to multiply, and lock the transparency so color can be added later.

2. Adding color

Paint the base colors in on a layer below the line art. Adjust them to make sure they work well together, and be sure to inspect the edges and corners carefully.

3. Adding shading

Create a shadow layer on top of the base colors. Below the line art set it to multiply, and use the darker colors from before. Add a mask to the shadow layer to make shading more manageable. Add highlights and darker shadows as appropriate. Create new layers for adding patterns to the kimono, "obi" (belt), and fan. Experiment with the layer settings—try setting the layer to color burn, or overlay.

DEMO: TEXTILE PATTERNS

Step 1: Layering patterns is fun! Do the shading as normal.

Step 2: Put a pattern on another layer over the top. Paint it on, or use other tools.

Step 3: Choose a layer setting that complements, and makes the pattern blend with, the coloring and shading beneath.

013 Festival girl

See also

Great digital manga babes: 20 tips, page 20
Clothing and accessories, page 26

Say yo to Yumiko

To little Yumiko-chan, there is no greater joy than witnessing the beautiful cherry blossoms in full bloom between late March and early April, when the cherry blossom festival is held. "Hanami," as it is known in Japan, is an event Yumiko and her friends look forward to all year. When the day arrives, they just chill out and relax: sitting in Tokyo's Ueno Park from day to night taking in the view; parading around in beautiful yukata robes; sipping sweet rice wine; eating dango dumplings; chatting to cute boys; and just generally having a ball! And because it only comes once a year, Yumiko is always determined to party enough within those fleeting two weeks to last her until next time!

Character details

Hair: Pigtails tied with a detailed dice-and-ball hair-bands.
Clothes: Intricately patterned "yukata" robe.
Accessories: A fan with a huge Japanese character design and a paper lantern.
Details: Japanese wooden geta clogs and tabi socks.

Tips on this style

The cherry blossom viewing festival is a big deal in Japan, and occurs frequently in anime and manga. Traditional attire is a light, airy robe known as the yukata. Yukatas are often mistaken for the more extravagant robe called the kimono. While yukatas are less showy and expensive than kimonos, they are often beautiful in their own right, with detailed, intricate print designs typical of Japanese fabric. Give the character accessories like a hand fan and paper lantern, and a fully-fledged festival girl has been created!

ABOUT THE COLOR PALETTE

Soft pinks blend with a delicate white pattern on her yukata. A contrasting yellow obi anchors the details, like the touches of bright red on hair and shoes. The bold black and red fan signals a serious meaning in a whimsical outfit.

Character studies

Yumiko is young, and her energy shows in her face and even in the way her pigtails spring out from the top of her head. Try a different expression on each view to find her best look.

Artist's shortcut

Scan or trace this:

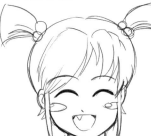

⬤ Head-on view

This laughing face features closed eyes and both pigtails in full view.

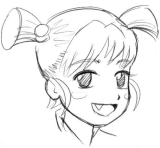

⬤ Three-quarter view

Her eyes show her personality as she looks out at the viewer here.

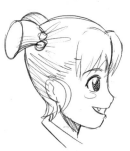

⬤ Side view

Her nose is just a small bump in this profile version.

DEMO: FABRIC FOLDS

Step 1: Start by preparing the robe's base coat of color—in this case, a white to purple gradient fill.

Step 2: With Illustrator, create the pattern. Copy and paste it into Photoshop on a new layer. Position this layer until it looks correct, and cut out the sleeves to give the impression of an overlap.

Step 3: Add the layer mask used for the base color to the pattern layer, and apply the screen blending option. You can now toggle the color settings on both layers and experiment. Finally, apply the shading layer and then blend it into the layers beneath by using the multiply option.

1. Line art

When creating the line art, the emphasis is on getting the clothes correct. Ensure the lines convey the yukata's looseness, and that it drapes naturally. Also take note of the pigtails, and how they pull the hair back tight.

2. Adding color

To give the yukata a more luxurious look, a gradient fill of two relatively contrasting colors can be applied to the fabric, giving it an extravagant look. In this example white and purple have been chosen, complementing the yellow sash. Notice how the light, sandy hair and the pinewood clogs help to balance the overall color composition, as well as harmonizing with the yellow of the torso.

3. Adding shading

The finer details are all added at this stage, bringing the final render to life. Details like the dice hair-bands, the fan with the giant "kanji" character, the delicate paper lantern, and the cherry blossom print all help to make Yumiko look the part. Refer to the demonstration (right) to understand further how to render a detailed patterned fabric like this.

014 Shinto bride

See also

*Great digital manga babes:
20 tips,* page 20
Clothing and accessories,
page 26

Meet Shiori

Shiori has always wanted to get married. So, when her boyfriend proposed, she was ecstatic and began making plans for the wedding immediately. Shiori has a romantic and traditional soul, and because she is a girl, she has dreamed of having a traditional Shinto wedding ceremony just as her parents and grandparents did. Even though most of her friends are now opting for Western-style weddings with enormous princess dresses, Shiori feels elegant and dignified in her traditional attire.

Character details

Hair: She is a classic Japanese beauty with natural-colored black hair.
Skin tones: Soft light skin, almond-shaped eyes, and a well-shaped mouth with full lips.
Clothes: The bride wears a kimono and hood made of white silk. Her hair is up in a traditional style and held with combs and ornaments.
Details: She sits on a small chair, with the precious fabric of her garment flowing down her body.

ABOUT THE COLOR PALETTE

A Shinto bride wears a beautiful white garment; the satin reflects different colors. Her hair is black, with a purple shine. The saturation of her skin color is not too bright, due to the reflection of the bluish-white head covering.

Character studies

Shiori's long eyelashes flare out like wings from her eyes. Her thin, gently curving eyebrows are placed high on her forehead. The large hood gently encloses her elaborate ceremonial hairstyle.

Artist's shortcut

Scan or trace this:

○ Head-on view

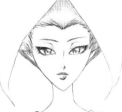

Her face shape is a delicate heart. Her slightly closed, deep-set eyes give her gaze a faraway look.

○ Three-quarter view

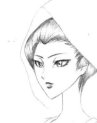

She has high cheekbones, and her hair is pinned up ceremonially.

○ Side view

Her lips are full, but her mouth is small. She looks elegant and ladylike.

1. Line art

Draw the outlines with a black colored pencil on 80 lb (120gsm) tabloid size (A3) Neusiedler color copy paper. Scan the outline at 600dpi in grayscale, and improve the contrast and remove any fluff or dust with the Brush tool. Using levels, ensure the white of the paper is clear and clean in the computer image.

2. Adding color

Work with several layers for coloring the illustration. To see the layers, select the background layer where the line art is placed and, using the Magic Wand tool, select all areas that should become the same color. Create a new blank layer, and fill in the color via edit, then fill. Set the transparency of the layers to lock so that you don't go over the edges when shading later.

3. Adding shading

Copy the garment layers and lay each copy above its original. Fill the copied layers with white and change the mode to multiply. The white areas should become transparent. Paint gray-green shadows on her garment. For highlights on hands, hair, and eyes, copy the relevant layers, but color them black instead of white and change the blending mode to screen. Paint highlights with a light color. Click on the layer where the line art lies, and paint color into the remaining black outlines. For the garment use gray-blue, for her skin gray-brown, and for her lips pink.

DEMO: EMBROIDERY

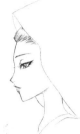

Step 1: For the kimono embroidery use Japanese patterns, combined in one image. The patterns start out black.

Step 2: Cut out the pattern around the garment edges, copy, and paste it into Quick-Mask-Mode. When leaving this mode, invert the selection, create a new blank layer, and fill with white.

Step 3: Now the lines of the pattern are plain white. Use gray-blue to color some parts of the pattern line to create a satin-like effect.

Grandma

See also

Colored pencils,
page 14
Proportion and scale,
page 24

Greetings from Grandma

Grandma has lived a long life, and she's been through plenty of hard times. She may no longer be the babe she was in her youth, but a positive attitude and good sense of humor have kept her cheerful and youthful in attitude. Her grandchildren are her sunshine and she's always very happy to have them visit. She fills her time by tending to her flower garden, which is small but beautiful.

Character details

Hair: In her youth Grandma's hair was black, and in old age it's turned gray. It's tied in a bun so it won't get in the way while she's gardening.
Skin tones: Pale, but with warm, rosy cheeks.
Accessories: Due to her posture a walking stick is essential. A short staff holds more character than a carved cane.
Color scheme: Plenty of bright, warm colors, especially shades of red, but slightly faded to create an aged look.
Details: A simple floral design adds variety to the pattern on the kimono, but be careful not to overdo it as the existing pattern is quite busy. The haori, with its single base color, allows more scope for a bright, multicolored, floral design.

ABOUT THE COLOR PALETTE

The colors on the kimono are bright, but neutral, with earthy greens and soft oranges. In contrast, the obi and haori are more vibrantly colored, with bright greens, reds, oranges, and yellows, but the softness of the shading creates an aged effect. The rosy parts of her skin are more of a warm peach color than pink.

Character studies

Age causes deep wrinkles, particularly in the corners of the eyes and mouth and along the forehead (especially if the eyebrows are raised). Be careful not to simply draw a young face and add wrinkles, though!

Head-on view

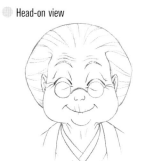

The large eyes and smile work in contrast to the small, pug nose to give Grandma a kind face.

Three-quarter view

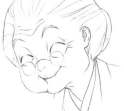

A slight bow makes her facial expression appear even more friendly.

Side view

Grandma is slightly hunched and round-shouldered, so don't forget to draw her neck with a slight forward curve.

Tips on this style

Grandma is a traditional woman so she wears a kimono. Make sure you draw the kimono with the left side crossed over the right—the only time the right side is crossed over the left is when the wearer is deceased! Grandma is also wearing a haori (jacket) and tabi socks, neither of which is normally used as casualwear.

Artist's shortcut
Scan or trace this:

DEMO: TEXTILE PATTERN

Step 1: Use a light colored pencil to draw the outlines of your fabric pattern.

Step 2: Carefully apply the base color. A slightly more solemn base color will give you a good contrasting base for your color scheme.

Step 3: Use bright colors to fill in the pattern. The darker base color will make them appear more vibrant.

1. Line art

Create softer lines by drawing your sketch with a black ballpoint pen. To make it easier to draw small details, draw your sketch on a tabloid (A3) sheet of paper.

2. Adding color

Colored pencils are best for applying bright but faded colors. Use light pressure on the pencil while coloring, and build up several layers of color to create a smooth, even finish. You may also want to apply the lightest colors first, as highlights are almost impossible to add with colored pencils.

3. Adding shading

Figure out where you'll be applying shade and continue adding darker colors by the same method you used before: building up layers of color while only using light pressure on the pencil to create a smooth gradient.

016 Temple maiden

See also

Great digital manga babes: 20 tips, page 20
Clothing and accessories, page 26

Meet Mari the Miko

Mari is a bright, cheerful teenager whose father runs the local shrine. She is happy to help her family as a shrine maiden (or "miko") during festivals ("o-matsuri") and other special events. She loves the excitement and fun! She is friendly and popular in her neighborhood, and goes out of her way to help others.

Character details

Hair: Long, lustrous, and shiny, Mari takes good care of it, sweeping it into a high ponytail to keep it out of the way.

Clothes: She wears traditional dress, called the "Chihaya," consisting of red hakama pants, a white kimono top, and white tabi socks with geta sandals.

Accessories: She is waving a "gohei" wand: a stick with zigzag paper attached, used in purification ceremonies.

ABOUT THE COLOR PALETTE

Beginning with a simple color scheme of red, white, black, and medium skin, choose highlights and shadows with a good amount of saturation to give your character vibrancy. Avoid grays and blacks, instead choose pinks, blues, and browns.

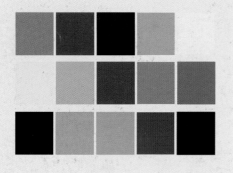

Character studies

Mari has a sweet and open face. Remember to keep her eyes wide and cheerful and her smile bright. Also take care with foreshortening when rendering her thick hair.

Artist's shortcut

Scan or trace this:

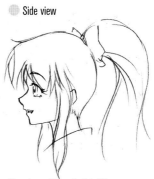
Head-on view

Take care when rendering a ponytail from a front-on view.

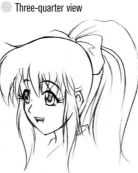
Three-quarter view

Show off her voluminous hair.

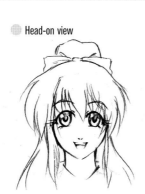
Side view

Keep her wide smile bright!

DEMO: HAIR

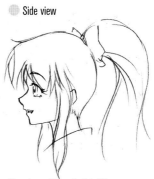

Step 1: Hair is tricky to get right. Start with the main base color.

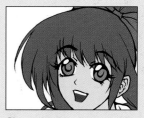

Step 2: Add shadows, mixing blocks of hair with thinner strands.

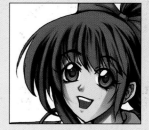

Step 3: Add overall gradients and sharper highlights, but do not go overboard!

1. Line art

Pencil Mari on paper using 0.5 mechanical pencils, ensuring detail is clear and sharp. Then ink her with a combination of 0.05 and 0.1 fine liners in black. Subtle variations in line weights give the line art a three-dimensional look, even without shading. Focus on using smooth, confident lines. Overlap if you wish; mistakes can be erased digitally. Scan it in, and then clean it up by adjusting the levels.

2. Adding color

If working anti-aliased (if the line art has a slight soft or blurred edge this gives it a smooth look on screen), add color by creating a new layer underneath the line art. Make selections on the line art, expand the selections by a few pixels, then drop the Paint Bucket on the layer below. Inspect the edges and corners, carefully filling in any missed patches.

3. Adding shading

Once the base color layer is finished, duplicate the layer and rename it "shadow." Set the layer to multiply, and Paint Bucket the colors with darker shades. Once the whole picture is darkened, add a mask to the shadow layer and begin etching. This means only having to concentrate on the lighting using black and white on the mask layer, rather than having to select different colors each time. Use brushes with varying hardness and opacity.

017 Punk rocker

See also

Inspiration, page 10
*Great digital manga babes:
20 tips*, page 20

Rock out with Ana

From the venues she frequents to her trendy fashion statements, Ana is a quintessential modern rock chick! Being a lover of eclectic music, she aspired to be a musician from a young age. Her musical destiny was sealed from the moment she picked up her first guitar, bought by her father for her eleventh birthday. Making up one quarter of the acclaimed rock outfit "Missiles a Go-Go," Ana leaves jaws on the mosh-pit floor whenever she performs. Not only is she living proof that girls rock harder than boys, she is also an inspiration to all young guitarists, being only sixteen and already a globally-worshipped guitar heroine!

Character details

Hair: Jet-black hair with a big rose headband.
Clothes: Heart motif print on a hooded sweater.
Accessories: Mirror-plated belt, headphone wires, and a ball chain.
Details: Half-length tights.

ABOUT THE COLOR PALETTE

Cool black and gray give way to warm gray tights, adding a ruddy blush to her legs. Her bright blue eye looks out warily from a black and white field, while her rosy red headband gives the lie to the cynical red heart on her chest and the metallic accents at her waist.

Tips on this style

There are many different rock fashion styles representing different subgenres of the alternative music scene, but the punk emo look that Ana sports is one of the most contemporary looks. The style derives from the Emotional Hardcore punk scene, popular in America and hugely influential on the alternative fashion scene. This style takes its cues from various forms of alternative fashions from the past: the black clothes against pale skin from goth rockers; the tight apparel and metal-plated belts from the original punks; and the audacious hair from the new romantics.

Character studies

Fittingly for a punk rocker, Ana has a sullen and challenging expression. Her hair always hangs over one eye and a skull earring is visible at her left ear. Take care over the positioning of the earring and headband.

Artist's shortcut

Scan or trace this:

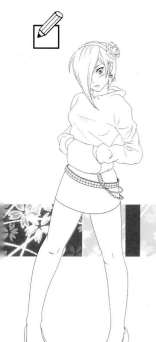

Head-on view

Her mouth is just a straight line and she looks the viewer right in the eye.

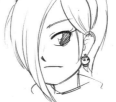
Three-quarter view

Take care when drawing her headband; it should tuck in neatly behind her ear.

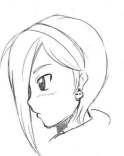
Side view

Pay attention to where her hair falls across her face; also get the length right.

1. Line art

For the punk look, ensure that her clothes are tight and figure-hugging. Spend time on the detailed accessories, such as the metal-plated belt or, alternatively, a studded belt. Popular punk emo symbols, such as skulls and hearts, are also appropriate.

2. Adding color

Limit the color palette. Stick to blacks and grays for the clothing, and make the skin tone a shade paler than usual, to achieve a semi-gothic look. Apply rich, bright red on selected parts of the ensemble, as shown in the above figure. This white, black, and red combo is visually arresting and fitting for the punk emo look.

3. Adding shading

A lot of shading and highlighting is concentrated on the legs. Legs are hard to shade because their shape and contour is complicated; knees are often a sticking point. Refer to a source, and vary the hardness of your brush to achieve a natural look. There is no need to shade the tights separately. Simply place them over the skin layers and overlay them with the multiply blending option to make them see-through.

DEMO: MOTIF

Step 1: Before adding the motif have the sweater prepared. With Illustrator or Photoshop, design the motif as a separate file. In this case, a heart with black tar dripping over it.

Step 2: Import the motif into Photoshop. Make it bigger than you intend it to be. It is easy to reduce an image later, but scaling up causes graphic quality to degrade.

Step 3: In Photoshop, use the Perspective tool to place the motif on the sweater beneath the shade layers. Toggle the multiply blending option for any shade layers above it. Use the Smudge tool to nudge the motif into the creases of the sweater.

018 Wacky

See also

Inspiration,
page 10
*Great digital manga babes:
20 tips,* page 20

Say okey dokey to Toki Doki

This girl is a mystery wrapped in an enigma. No one knows her real name, who she is, or even what planet she is from! All that is known about this strange being is that she crops up sporadically in Tokyo's videogame, anime, and shopping Mecca "Akihabara." The locals call her Toki Doki, which means "now and then." She never utters a word, but she will play anyone on any arcade machine, and has never lost a match. Her mysteriousness, unorthodox appearance, and flawless videogame prowess has ensured her legendary status in Akihabara. Tourists from all over the country visit just to catch a glimpse of her. If you do spot her, don't get too close; that phaser she carries is no toy, as a few unfortunates have found out the hard way...

Character details

Clothes: Fur-ball pilot hat and overalls.
Accessories: Retro plastic toy gun, cool mini button badges, plasters, elbow pads, and a wristband with a feather.
Details: Double belt combo, thick and thin, with fat belt buckle, and logo.

ABOUT THE COLOR PALETTE

A sweep of intense red is interrupted by white: a belt, hat, and big shoes. Dark blue hair frames her happy features. Bright multicolored accessories cluster above her hips, where more red in varying shades is also found. A T-shirt and her skin tone create a neutral zone to relieve the busy detail.

Tips on this style

Wacky has a very loose theme, with a mishmash of conflicting fashions offering plenty of choices! Be instinctive, and lavish the character with intricate details. Just make sure that the feel is playful and fun. To achieve this, Toki Doki has a retro toy gun and lots of little incidental, cute details, such as the badges and belt buckle. Think clowns, minus the bad perm and scary face paint!

Character studies

The hat and the wide-eyed expression leave little extra room on the face, so drawing in all the details will take some care. Position the pompom after all views are done.

Artist's shortcut

Scan or trace this:

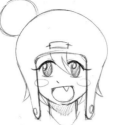
● Head-on view

Draw the front view first to fit the features and hair onto the round covered head.

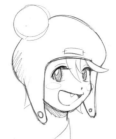
● Three-quarter view

In between the side and the front view.

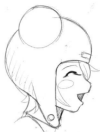
● Side view

The hat fits the head closely enough so that the side view shows its length.

1. Line art

Begin by getting the figure down before going to town on the details. This way, mistakes can be corrected to the body, without having to amend the accessories. Because this is a wacky character she has a very expressive, cartoon face, with a slightly oversized head. Spend time working up the accessories; detail makes characters convincing individuals.

2. Adding color

A bright, exciting color scheme was used to give expression to this fun-loving character. Big dungarees are reminiscent of clowns, and the white hat, belt, and shoes work well against the red and help balance out the overall scheme. For the other items go with whatever color works best, and do not worry about clashes. The whole point is that this character is crazy, and so is her wardrobe!

3. Adding shading

To get a very refined anime cell-shaded look, soft brushes were avoided, leaving only hard, block-filled edges. This is a good technique to avoid making any of the shading look too "realistic." Finishing details include a healthy dose of shiny light reflecting on any smooth surfaces.

DEMO: CHECKS

Step 1: Get the base color of the wristband ready before proceeding. In this case, pink shading on white, giving the item a light pink look.

Step 2: On a new layer draw a grid in dark pink, following the contours of the wristband. For the checks, erase every point where a horizontal line meets a vertical line.

Step 3: If done correctly, it will look something like this. Finish off by putting shiny reflections on the little balls, and color the feathers in with a soft, delicate brush.

019 Hip-hop

Representin' Reiko

Reiko is a huge fan of American hip-hop music, which has pervaded the Tokyo youth scene. She avidly watches music videos in order to copy her idols' sense of style and attitude. On weekends, she browses specialist hip-hop boutiques in the ultra-trendy Tokyo districts of Shibuya and Harajuku, then spends the entire night clubbing in Roppongi. She's an excellent dancer with a naturally toned body. Her dream is to travel to New York and build a career as a model or dancer.

Character details

Hair: Dyed brown and loosely curled into a side ponytail.

Skin tones: Very tanned, smooth, and shiny. Urban cities often lack locations or opportunities to sunbathe, so many cosmetic products ensure that girls can maintain a realistic fake tan all year round.

Accessories: A trucker cap is an essential accessory in any hip-hop wardrobe, worn here under a hoodie for extra attitude. Large hoop earrings are popular jewelry as they project "street style" rather than "high class."

Color scheme: Blue denim and faded red cotton provide a casual daytime look, and pink highlights give it a girly touch.

Details: Hip-hop wouldn't be hip-hop without "bling," so a bejeweled belt buckle becomes a statement piece for the outfit. Footwear is usually flat and comfortable, the most popular being designer trainers or Timberlands. Reiko is wearing Ugg boots, an all-purpose shoe that's been adopted by stylish girls worldwide.

Tips on this style

Hip-hop is extremely popular in Japan. There are many shops, clubs, and even manga dedicated to this theme. The key to hip-hop style is mixing comfort with sexiness. Clothing is often oversized and slouchy, making it difficult to express femininity. Reiko solves this by showing just enough skin to emphasize her figure, but keeps the rest casual.

ABOUT THE COLOR PALETTE

Colors mimic the American flag, which emphasizes the origin of this style. Brown is perceived to be a "neutral" color when viewed on a human body, because it's similar to hair or skin. You can use shades of brown for clothing or trimmings if you don't want those areas to clash with a brighter palette.

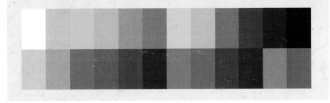

Character studies

Drawing a cap at the correct angle poses an extra challenge for this character. Care also needs to be taken when designing an asymmetric hairstyle: the character may look good from one angle but be impossible to draw from another!

● Head-on view

Pouty mouth with full lips.

● Three-quarter view

Don't be afraid to cover elements you've already drawn. In this case, the cap brim obscures the eyebrow, which was then erased.

● Side view

The ponytail from the side.

✎ **Artist's shortcut**
Scan or trace this:

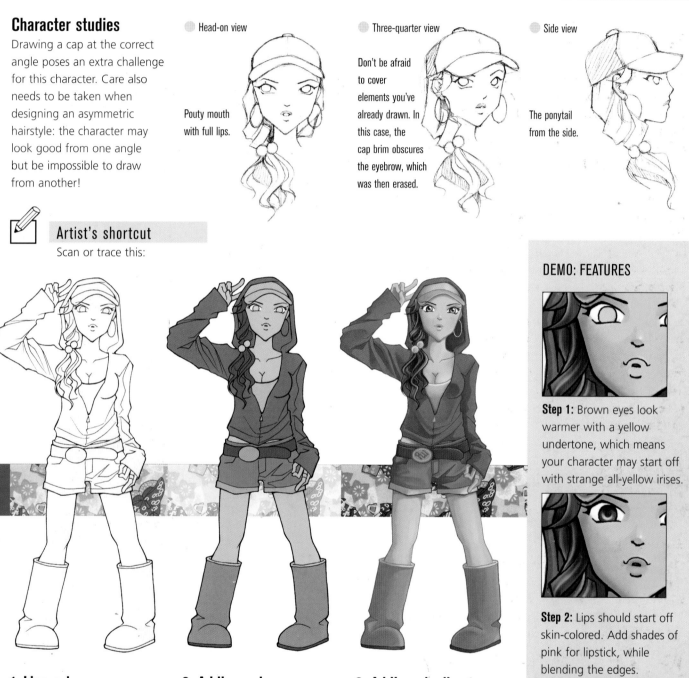

1. Line art
The outlines should be drawn by hand using a 0.1 fine liner pen. This allows maximum control when varying the line thickness. Prominent contours, such as the face or body outlines, are made thicker than less important lines such as clothing folds. This creates extra depth in your line art and gives the final image "punch."

2. Adding color
This image is colored using OpenCanvas, a graphics program developed especially for manga illustration. The colors are blocked in using the watercolor brush. If possible, try to keep each distinct area of color (skin, hair, shoes, etc.) on separate layers, because this makes shading and editing easier.

3. Adding shading
The shading is done using the Watercolor and Airbrush tools. The combination of these creates a very smooth, digital finish. As a final touch, the outlines have also been colored in with a tone slightly darker than the color next to it. This is a great technique to "soften up" an illustration.

DEMO: FEATURES

Step 1: Brown eyes look warmer with a yellow undertone, which means your character may start off with strange all-yellow irises.

Step 2: Lips should start off skin-colored. Add shades of pink for lipstick, while blending the edges.

Step 3: Highlights really bring the face to life. Make sure that the direction of your highlight corresponds with the lighting angle of the whole image.

Elegant gothic

See also

Great digital manga babes: 20 tips, page 20
Clothing and accessories, page 26

Say ciao to Chiaki

Descendant of a legendary Japanese vampire lineage, Chiaki is the result of an illicit love affair between the late vampire king and his mortal lover. Being half vampire and half human, Chiaki has struggled with her identity all her life, and has failed to find the acceptance she so craves. Since the death of her birth mother, her father, the vampire king, vanished into the darkness never to be seen again. Now little Chiaki resides in the grand castle alone, destined to live out an eternity without ever knowing what it is to love and to be loved.

Character details

Hair: Highly detailed, doll-like ringlets.
Skin tones: Pale and muted for an ashen, vampire look.
Color scheme: Vivid teal-colored eyes, rosy cheeks to emphasize a sense of youthfulness, dark gothic clothing.
Details: Family heirloom attached to a thick chokerlike necklace.

Tips on this style

The Japanese interpretation of gothic is different from the Western take on the style. The term gothic is synonymous with stylish fashion in the East rather than latex, long hair, and death metal. "Elegant gothic" is a trendy subculture in Japan (spreading across East Asia), and its influences are slowly seeping into Western fashion (where they are referred to as "gothic fairytale"). If you're a die-hard anime fan, chances are you already know the score. If not, think French Maid mixed with Alice in Wonderland to get an insight into the look.

ABOUT THE COLOR PALETTE

Use a limited color palette to accentuate the elegant gothic visual style. Avoid garish colors.

Character studies

A simple dress design has been chosen so that the shading/highlighting process will not be too demanding (elegant gothic fashion has a knack for being complex in design). However, the inclusion of frilly trims are mandatory to authenticate the look.

Artist's shortcut

Scan or trace this:

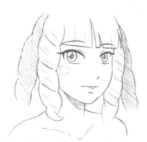

Head-on view

Cute button nose.

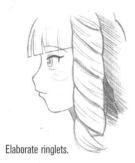

Three-quarter view

Face left simple to express the smoothness of Chiaki's features.

Side view

Elaborate ringlets.

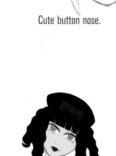

DEMO: HAIR HIGHLIGHTS

Step 1: Start with the highlighting of the hair.

Step 2: Add blocks of white in the light areas, and then use a Smudge tool to smudge the white into place.

Step 3: Follow the flow of the figure's hair.

1. Line art

The elegant gothic look demands precision. Consistent sharpness and weight of line art are important. The hair is the most complex element of this render, so it's worth investing time to make sure that every ringlet curls in a coherent way. This will also make the highlighting process a lot less laborious.

2. Adding color

Keep colors as simple as possible. A large palette won't work with this delicate piece. Keep colors muted with only a hint of color saturation in order to achieve a near-monochrome look.

3. Adding shading

The rendering is the trickiest part with this character. Because her dress is puffy, you'll need to emphasize the curves with articulate shading. Use a soft brush to achieve a decent gradient effect that highlights the curves effectively. Layer on a tartan pattern to the skirt.

 Cyborg

See also

Colored pencils,
page 14
Marker rendering,
page 15
Combining media,
page 17

The mechanics of Maria

Maria was a highly skilled Shaolin martial artist with many enemies. Following a battle with her arch nemesis, she was very nearly killed when she fell from the roof of a building. Left for dead, a scientist stumbled across her broken body and took her back to his laboratory where he is rebuilding her as a cyborg. Maria is now part robot, and when the rebuilding is finally over she plans to hunt down her enemies and seek revenge.

Character details

Hair: Long and silky, and made from synthetic fibers.
Skin tones: Very pale—her skin is artificial, so there's no bloodstream to make it pinker, and she's never been outside.
Accessories: Not many at this stage, as she's just been reborn, but she still has cables attached as the process isn't quite complete.
Color scheme: Soft, cool pastel colors.
Details: Not all her skin has been added, so parts of her robotic skeleton are still visible. Keep the structure of the human skeleton and muscular system in mind when drawing these exposed portions.

ABOUT THE COLOR PALETTE

A cold but bright pastel color palette is ideal for conveying a futuristic, clinical ambience. Use a very light purple instead of pink to shade her skin and give it a cool appearance. Don't be tempted to simply color all the mechanical parts gray, as it will make them look flat. Add some depth and variety with grayish shades of brown and purple.

Character studies

Maria's character design is actually fairly simple, so the main benefit of character studies is perfecting her facial expression.

● Head-on view

Achieve a deadpan, aloof facial expression by leaving out the pupil in her eye and coloring or shading her iris with a smooth gradient, dark at the top and light at the bottom.

● Three-quarter view

Having one eye covered by her hair gives her more of an air of mystery and secrecy.

● Side view

Her forehead and the back of her head are both quite large, giving her a small, childlike face. Her small, slightly upturned nose reinforces this innocent look.

Artist's shortcut

Scan or trace this:

Tips on this style

The process of transferring consciousness from a human body to a mechanical one is a stressful experience, and that should be reflected in Maria's expression. Her eyes are glazed and empty, giving her a look of innocence and apathy. It's reflected in her new body, too, which looks frail and delicate.

1. Line art

Make a sketch on letter size (A4) paper and enlarge it to tabloid (A3) size with a photocopier, then trace a clean version. Use a 0.05 fine liner to draw the body and details, but use a black ballpoint pen for the hair to create softer, silkier strands. Use color copy paper with a weight of 80 lb (120gsm), as its smooth surface will allow you to draw very precise lines.

2. Adding color

Color the mechanical parts, eye color, and parts of the skin tone using fine-tipped markers. Trace along the black outlines and draw the background pattern with a light blue, fine-tipped marker. For the hair, use a soft, brush-tipped marker, as it's ideal for coloring hair strands and making slight color gradients.

3. Adding shading

Shade the hair using a light blue colored pencil. Be careful not to use a pencil that's too soft, as it'll be difficult to keep the point as fine and sharp as you need it. Use pastel chalk to achieve a soft, pale finish on the skin. Shade the mechanical parts with dark gray watercolor paint, and use opaque white ink to add highlights.

DEMO: FEATURES

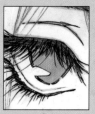

Step 1: Draw light blue lines along the black outlines to soften the image.

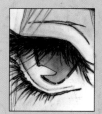

Step 2: Apply the chalk (for the skin tones) to the tip of a paper stump and smudge it onto the paper. For larger areas, use a kitchen towel.

Step 3: Color the eyes with a purple colored pencil. For highlights, use an opaque white ink that is liquid enough for painting thin lines, but which will cover underlying colors sufficiently.

 Angel

See also

*Great digital manga babes:
20 tips*, page 20
Choosing color palettes,
page 22

Bow your head to Ariel

A normal girl by day, at night after she falls asleep Ariel transforms into a benevolent angel—a graceful, effortless being. Neither friends nor family know about this nocturnal transformation because Ariel's physical appearance is completely changed. Ariel has no memory of her nighttime adventures in the morning when she wakes, but by night she is a mysterious force for good, touching the lives of many of those around her.

Character details

Eyes: Bright green.
Hair: Long and golden, glowing with light.
Clothes: She wears a long white robe with trailing ends.
Details: She has bright white wings that appear to be feathered.

ABOUT THE COLOR PALETTE

An angel clothed in the colors of the heavens: golden sunlight, pale blue sky, white clouds, pink sunset glow, and gray stormy skies. This ethereal being does have human-toned skin and piercing green eyes, surrounded by light and airy white, with pastel blues and pinks.

Character studies

Ariel's wide-set eyes and long lashes are the most important features of her face. They curve across her face about half way between the top of the head and the chin.

● Head-on view

Notice her down-turned lashes.

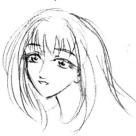
● Three-quarter view

Concentrate on making her hair flow elegantly.

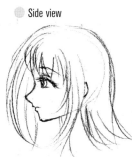
● Side view

Make those lashes sweep out!

Artist's shortcut

Scan or trace this:

1. Line art

Pencil sketch Ariel on paper using 0.5 mechanical pencils, and then scan the sketch. Ariel is then inked digitally at 1200dpi in Deleter Comicworks in pure black and white. Import her into Photoshop CS as a bitmap, and delete the white to create a transparent line-art layer, ready for coloring.

2. Adding color

Create a separate layer for adding the base colors, all in one go. Reserve an additional copy of the base color layer to help with easy selection further on, as this style of coloring uses lots of airbrush and gradients. Notice the use of different colored shadows for the other white in the picture. Do not stick to gray, choose pinks and blues.

3. Adding shading

Initial shading is done as a soft cel-art style with slightly blurred edges on a shadow layer set to multiply. Shading is easier if a mask is applied to the shadow layer. Additional depth is added by using the airbrush on the shadow and base color layers. Experimenting with Color Burn and Color Dodge in the brush settings can yield luminous results—the highlights and shadows have a lot more saturation.

DEMO: HAIR HIGHLIGHTS

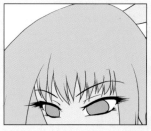

Step 1: To create soft, glowing highlights, start with a base color layer.

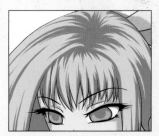

Step 2: Create a shadow layer on top, and set to multiply.

Step 3: Returning to the base color layer, softly airbrush in pale colors with the brush setting on Color Dodge.

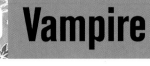 **Vampire**

See also

Creating great line art,
page 18
*Great digital manga babes:
20 tips,* page 20

Watch out for Lestatia!

Lestatia Krásnova was born in 650 A.D. in Samova Ría (now Slovakia). A promising violinist, she was bitten by a vampire–the granddaughter of the infamous, eternal Dracul–at the tender age of seventeen. Ever since, she has stalked the night in search of young blood to suck. She vows to share her immortality only with the One, whom she has yet to meet.

Character details

Hair: Dark, red, flowing.

Skin tones: Pale, white skin.

Accessories: Lestatia loves fashion accessories, and they vary according to her mood. But she always carries her staff, which doubles as a tool for draining and storing her victim's blood, in case she needs a snack later!

Color scheme: Lestatia is wearing her purple and pink number. She varies her outfits from night to night. As a rule, she always has an element of black in her costume. She can be extremely seductive— why hunt prey, when you can make them come to you?

Details: The corset is held together by a metal bat motif, with a pink ribbon climaxing in a big bow on her back. Her boot heels make an excellent flesh-piercing tool.

ABOUT THE COLOR PALETTE

Using fairly neutral hues as base colors, pick out and mix darker and lighter shades using the color picker, to provide a wide variety of shades and hues, to add to the realism.

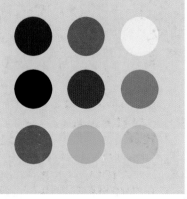

Character studies

The energy and intensity of the character comes from the eyes. Get these correct, and the rest should follow. Lestatia's moods vary from feral hunger, to desire, to loneliness.

Artist's shortcut

Scan or trace this:

⬤ Head-on view

Lestatia's hair is possessed by an evil, yet beneficent and style-conscious spirit.

⬤ Three-quarter view

Get carried away with detail and tangents; never keep it simple.

⬤ Side view

Contemplating the tragedy of her existence or planning tomorrow's outfit?

DEMO: HAIR HIGHLIGHTS

Step 1: Paint a few dabs of a darker and a lighter shade of the hair color in the direction the hair flows.

Step 2: Use the Smudge tool to fade out the dabs, using various brush sizes and strengths.

Step 3: Finish by using a brush at a low opacity, and the color picker to pick out other shades for definition. Carefully paint an outline, avoiding thick black lines.

1. Line art

Spend time perfecting the original pencil drawing, adding as much detail and texture as possible. Scan in the image, and then adjust the brightness and contrast so the lines and shading are clear.

2. Adding color

In Photoshop, trace over the scan using the Pencil tool and then fill with the Paint Bucket. This is a quick way of block filling the image with color, without yet worrying about the outline. Use as many layers and layer groups, as possible, labeling them as you go. This provides greater control over the image.

3. Adding shading

Superimpose the original sketch over these layers by dragging the layer over the others and setting the layer properties to multiply. Paint the details using the sketch layer as a guide. Use a variety of brushes, changing the opacity, hardness, brush size, and picking and mixing colors with the Color Picker tool.

Fairy

See also

Marker rendering,
page 15
Combining media,
 17

Make a wish with Mika

Mika is so small that she could sleep on your palm, but it is more likely that she will remain hidden because when she flies she is transparent; just a small glimmer of light in the air means she may have decided to show herself! If you do see her, it's best to remain calm and to listen to her whispered words. Maybe she will ask about a deepest wish, and grant it with a gesture of her hand and a sweet smile.

Character details

Hair: Her hair resembles elegant plant tendrils, as if she is half-human, half-vegetation.

Skin tones: Warm with light, organic green patterns on the skin, which give her a pretty, fresh appearance.

Details: Because she is a fairy, Mika has translucent wings with an opalescent sheen. She is tiny, only about 4–5 in (10–13cm) tall. Her body is slender and agile.

ABOUT THE COLOR PALETTE

Use soft, pale colors for Mika. These colors are reminiscent of iridescent nacre or white opal. The main colors are rose, light green, and brown.

Character studies

Mika's expression should be otherworldly and dreamy. Make sure you get her pixie ears positioned correctly on her head.

Head-on view

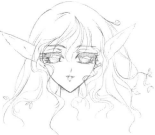

The omission of the pupils, and the slightly lowered eyelids, make her appear as if lost in reverie.

Three-quarter view

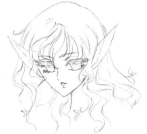

Her face is delicate and soft. She has no cheekbones, but the chin is pointed, so she looks elegant.

Side view

A slightly open mouth and the curve of her upper lip make her look sweet. The space between the jaw and neck is defined.

Artist's shortcut

Scan or trace this:

1. Line art

Working on 80 lb (120gsm) tabloid size (A3) satin Neusiedler color copy paper, use a sanguine Copic Multiliner for the line art. Black would be too overbearing in relation to the artwork's soft colors.

2. Adding color

Use the lightest colors in the Tria marker range for the base colors. The organic green patterns are drawn over the already painted skin. To create the mint-colored spots on her wings, use the soft brush nib of Copic Ciao.

3. Adding shading

Chalk pastels are applied using a paper stump. Gather the powdery residue from the pastel chalk on the paper stump and then apply it to the paper. Applying the chalk directly would look too rough. For larger areas apply pastel chalk onto some kitchen towel, and convey that onto the paper. On smooth laserprint paper, pastel chalk looks very soft.

DEMO: FINESSING

Step 1: First, apply the skin color. Then, take a pale pink Tria marker and trace along the outer and inner sides of the outlines. This gives the artwork a soft, blurred look.

Step 2: To deepen shadows use colored pencils, which are fuller and darker than soft pastel chalk. Use a paper stump to blur the lines.

Step 3: To apply highlights use a small, pointed brush (synthetic-hair) and opaque white ink. For subtler highlights use a soft white crayon. The glossy shine on her lips makes her mouth fuller. The dewdrops on her body look cute and dainty.

Witch

See also

Great digital manga babes: 20 tips, page 20
Choosing color palettes, page 22

Meet Rina

Rina is an apprentice witch. Bubbly and charming, Rina is always a ray of sunshine. She comes from a long line of witches, and is almost fully qualified. She is hard working and talented, but her happy-go-lucky attitude doesn't always go down well at school.

Character details

Hair: Bright bubblegum blue in a long style.
Skin tones: Fair and delicate, but with a very slight rosy tint.
Accessories: She always has her broom, essential for getting around, along with a traditional witch's hat, black shawl, and black velvet boots.
Color scheme: Along with traditional black, a more light-hearted pastel pink.
Details: The pink ruffles and bows on Rina's outfit reflect her charming and bubbly personality, and her girlish side. She also wears a cute miniskirt and lace-topped stockings.

ABOUT THE COLOR PALETTE

This arrangement plays with black by applying it as a gradient and uses different tones for shadow and texture. Her bright gold hat trim frames her face and lightens the black hat. Feminine pink accents her garters and trims her bodice and sleeves. A white blouse adds youthfulness.

Character studies

The character's hair flows in different directions. Draw different lines showing the flow of hair. She is also shown winking. This fun gesture points to her bubbly personality.

● Head-on view

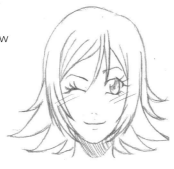

● Three-quarter view

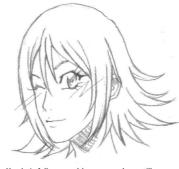

● Side view

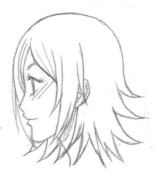

Her hair frames her face and her winking eye shows her bright personality.

Her hair falls around her ear, and we still see a lot of her left eye.

Her profile shows her slight, good-natured smile.

Artist's shortcut

Scan or trace this:

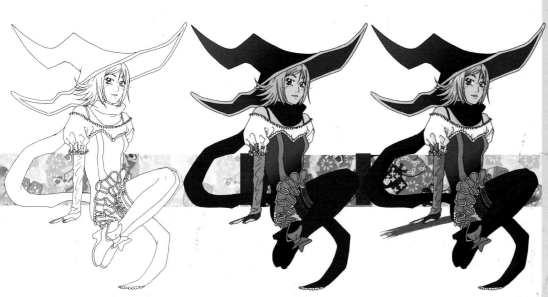

1. Line art

The line art is first drawn out in pencil, then inked, and finally scanned into Photoshop as a black-and-white file. Once in Photoshop, change it into a color file.

2. Adding color

Select the different areas you want to color by using the Magic Wand tool. Color the selected areas using the Fill Bucket tool on Photoshop. Lots of different tones of black and gray are used here.

3. Adding shading

The shading is created with the Brush tools. Remember that every surface casts shadows. Use gradients of black for shading black items. This style creates the traditional CG look.

DEMO: FEATURES

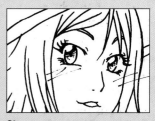

Step 1: Scan in the work as a black-and-white file into Photoshop. Change it into a color file.

Step 2: Fill in the basic color. Decide where the light source is to come from.

Step 3: Using the Brush tool draw out the shades, and give the character's skin some glow, highlighting the hair, and providing the lips with some color.

026 Superhero

See also

Inspiration, page 10
*Great digital manga babes:
20 tips,* page 20

Be super to 7L!

7L, also known as Lenevés Kaster, crash-landed on Earth in a metal comet from an unknown planet when she was a baby. A stranger to her past, and to her powers, until early adulthood, she discovered them while meditating on Mount Vesuvius. Her third eye burst open in a jet of flames, and her powers of flight and superhuman strength were revealed. Which is just as well, because her arch-nemesis, Knemesis, the planet-eating robot virus that destroyed her home, is on his way to Earth and only 7L can destroy him!

Character details

Hair: Strawberry, honey blonde, and mousy brown.
Skin tones: A Caucasian with a Mediterranean tan; sullied here because she is fighting.
Accessories: Cybernetic earpiece that blocks Knemesis' devastating SyberSonicScream Blast and plays MP3s.
Color scheme: Girly pinks and purples; 7L has a right to assert her femininity because she is the strongest being on the planet!
Details: Little pouches on Lenevés' boots to store her crime-fighting gadgets.

ABOUT THE COLOR PALETTE

Because the character is shaded by the mouth, the base colors are quite dark and low in saturation. Using the color picker, build up the image with both brighter and darker colors.

Character studies

Start by designing the character's look and costume. After some figure studies—to find the most dramatic pose—begin the main sketch. With a pose in mind, start with the eyes, which dictate the face's position and in turn the body's position. Draw studies to get the trickier limbs, and the perspective, correct, as and when needed, and work these back into the main sketch.

Artist's shortcut

Scan or trace this:

 Head-on view

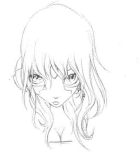

7L always scowls, because she is consumed by bitterness and a desire for revenge.

Three-quarter view

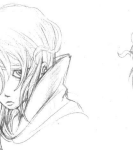

She wears a cloak to conceal her identity.

Side view

Meditation is the only way 7L can control the terrible power contained in her third eye.

Tips on this style

Graphics tablets—ideally those with integrated pressure sensitive screens—or table PCs are essential pieces of hardware for manga artwork. Being able to work directly on the screen gives you all the benefits of analogue painting, as well as all the advantages of working digitally.

DEMO: LINE DETAIL

Step 1: Block off each color section by using the Pencil, and Fill tools, staying as close to the original sketch as possible.

Step 2: This color stage gets quicker (remaining sections need no brushwork and just need to be filled). Make sure you set the Fill tool to acknowledge other layers.

Step 3: Overlay the sketch layer, and the job is nearly done.

1. Line art

It is important to get the original pencil drawing millimeter perfect, because in the end it overlays the finished piece, using the rough pencil texture to give the scene a gritty feel.

2. Adding color

Scan the pencil drawing into Photoshop, and carefully trace the image into a separate layer. Block sections of color, using the Pencil and Fill tools. This will create a base to paint on, and is an efficient way of selecting and working on separate sections of the image.

3. Adding shading

Using the original sketch placed on the highest layer with layer properties set to multiply and at a medium opacity, paint the details and shades on different, clearly labeled groups, and group layers. Being organized saves time; group layers together when you are sure you no longer need them separate.

021 # Beach babe

See also

Great digital manga babes: 20 tips, page 20
Proportion and scale, page 24

Meet Alika

Healthy young Alika loves nothing more than hanging out at the beach, soaking up the sun, and swimming in the sea with her friends. Her healthy tanned skin and shapely curves attract lots of attention from boys, especially when she parades around in a hot bikini! Yet Alika remains single by choice; she believes that most men are losers, and she tenaciously holds out for the ever-elusive Mr. Right to come along and sweep her off her feet.

Hair: Blue-gray hair that complements her skin tone.
Skin tones: Healthy, tanned, and golden.
Clothes: A skimpy blue bikini, ideal for a day on the beach. The blue tones in her bikini match her blue-gray hair.
Details: Strong highlights accentuate her perspiration.

Tips on this style

It was important that Alika looked like a lively, outdoors kind of girl. A healthy, robust body was a no-brainer, and the healthy skin tone adds to this. To further extend that carefree attitude Alika embodies it was very important not to accessorize her too much; the lack of extras imbues her with the sense of purity and freedom necessary to express her happy-go-lucky character.

ABOUT THE COLOR PALETTE

Alika's ruddy skin tone, with white highlights and warm shadows, contrasts with her blue bikini and cool gray hair. Careful modeling of the exposed body provides enough visual interest so that accessories are not missed and the natural girl is emphasized.

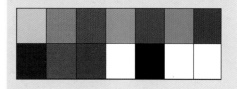

Character studies

Alika's expression shows her friendly attitude and happy nature. The lively hairstyle broadcasts her active outdoorsy style. Be careful to draw the ponytail and the cowlick in the right perspective according to the view.

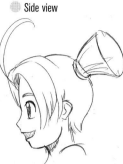

⬤ Head-on view

The hairstyle has been tamed a bit to show its construction.

⬤ Three-quarter view

In manga, the nose can shrink to a tiny pencil mark, while the eyes stay big.

⬤ Side view

Profiles show the proportion and placement of eyes and ears.

Artist's shortcut

Scan or trace this:

1. Line art

It is important to get Alika's shape right. The trick is to exaggerate her assets without going over-the-top. There is sexy curvy, and then there is unflattering curvy; make sure you achieve the former!

2. Adding color

As usual, begin by block filling the line art with the base coat colors. Use the Hue/Saturation adjustments in Photoshop to experiment with different color schemes.

3. Adding shading

The bulk of the work here is spent getting the skin to look right. To achieve convincing body contours, make sure you use brushes of varying softness: hard brushes for deep recesses and soft brushes for curves. To bring out the highlights, finish by using a relatively large, soft brush (with low flow). Be liberal with it, as the white on tanned skin gives the impression of shininess and moisture.

DEMO: HAIR HIGHLIGHTS

Step 1: Start by block filling the base color of the hair.

Step 2: Using a brush with full hardness, make tapered strokes by fully exploiting the pressure sensitivity of your tablet's stylus. This gives the impression of hair being parted in many directions.

Step 3: Create highlights with a soft, white brush, then select the Eraser tool with 100 percent hardness. Proceed with more tapered strokes through the white highlights.

 Tomboy

See also

Great digital manga babes: 20 tips, page 20
Choosing color palettes, page 22

Meet Keiko Ogawa

Keiko is a no-nonsense tomboy who just wants to chill out with her best friend, Miyuki Tanaka, and practice her karate. Keiko's uncle runs a karate dojo, and Keiko has been going there since she was very young. Keiko was in the top 10 in Japan's National Junior Karate Championship, and she aims to become top five this year. Keiko is in Grade 9, and lives with her parents. Her father is a fashion designer, and her mother is a karate instructor at Keiko's uncle's dojo.

Character details

Hair: Jet black, straight, and shiny, and worn long despite the fact she's such a tomboy.
Skin tones: Always on the move, Keiko's skin tone is healthy and bright.
Accessories: Keiko doesn't have any accessories. She doesn't like fussy embellishments and doesn't want to carry or wear anything that might cramp her style or get in her way.
Color scheme: Bright and bold, highly contrasting colors, definitely no pastel colors.
Details: She always wears a loose-fitting and comfortable tracksuit and sneakers.

ABOUT THE COLOR PALETTE

From a saturated leaf-green to black, the colors are basic and earthy, underscoring a preference for the physical and tactile. Stripes of contrasting color add energy, as do the strips of flying black hair around her head. Keiko's clothes are all business, reflecting her competitive and focused nature.

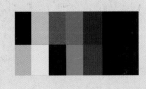

Character studies

The character has long black hair, not the traditional short hair usually worn by tomboys. She has a relaxed and open expression. Be sure to keep the proportions consistent.

Artist's shortcut

Scan or trace this:

○ Head-on view

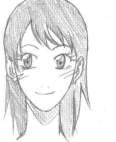

Wide eyes give her a youthful look. Her nose is drawn using just two tiny marks.

○ Three-quarter view

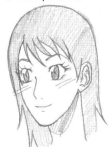

Her nose becomes a simple line and her mouth tilts up at the side to show off her slight smile.

○ Side view

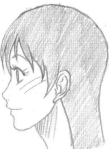

Her profile is youthful and her expression remains open.

DEMO: CREATING FORM

Step 1: Scan in the work as a black-and-white file into Photoshop. Change it into a color file.

Step 2: Fill in the basic color, and decide where the light source will come from.

Step 3: Using the Brush tool, draw out your shades, also adding a third shade, to create a more three-dimensional look.

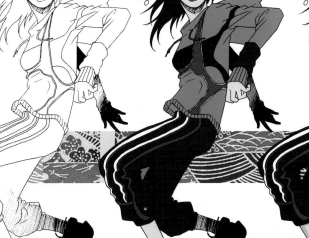

1. Line art

Inked by hand, the lines' width remains constant. However, giving more width to some areas will highlight them. For beginners it is best to keep the lines the same width, until familiarity with which areas should be heavier than others is achieved.

2. Adding color

Select the areas you would like to color by using the Magic Wand tool and then color the selected areas using the Fill Bucket tool on Photoshop. This figure uses highly contrasting colors in very much defined areas.

3. Adding shading

The shading is drawn in with the Brush tools. These provide better control over the shading process than the Magic Wand and Fill Bucket. The shading on the skin (beneath her chin and on her ankle) was retained from the line drawing and so is textured, whereas the digitally added shading on the clothes is very smooth.

029 Glamour girl

Alisha's pleased to make your acquaintance

Alisha is a true girly-girl and loves her high heels and handbags. Her diary is stuffed full of sample sale and fashion week dates, as well as hair and make-up appointments. She works for a high-end lifestyle magazine and feels it is part of her job to keep up with the latest trends (well, that's her excuse anyway). Her style is flirty, but she's an expert at keeping potential suitors at arm's length!

Character details

Hair: Dark brown hair swept up into a casual style. Loose strands give it a soft, flirty feel.

Skin tones: Lightly tanned and golden. Alisha loves body lotions that give her skin a shimmering sheen.

Accessories: A chunky bangle and cute necklace give the outfit a playful edge. Wearing costume jewelry was made popular by Coco Chanel and takes a tongue-in-cheek approach to luxury and fashion.

Color scheme: Soft peach, dusty blue, and olive green give the outfit a mature, understated vibrancy. There is a lot of textural contrast, from floaty chiffon to hard metallics.

Details: Matching your shoes to your handbag is a traditional way of showing style. Alisha makes a bold statement in having both accessories bright gold.

Tips on this style

Alisha's outfit is quite daring, but the boyish shorts offset the high heels and exposed skin. True glamour goes well beyond clothes and accessories. Girls who master the art of glamour will dedicate many extra hours to personal grooming, ensuring that their legs are always tanned and their eyebrows waxed, and would never ever let themselves be seen in public with chipped nail polish!

ABOUT THE COLOR PALETTE

Muted blues and greens enhance the shimmery peach top. Bright red and gold are kept to the accessories, creating an appealing but not overwhelming contrast.

Character studies

The features are delicate, with wide eyes and a small mouth. Eyebrows are trimmed and sculpted. Alisha would wear makeup everyday, which should be rendered through shading or screen toning on lips and eyelids.

Artist's shortcut

Scan or trace this:

○ Head-on view

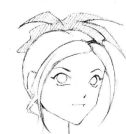

Heart-shaped face framed by tendrils of hair.

○ Three-quarter view

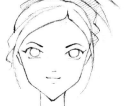

Thin lips and tiny nose.

○ Side view

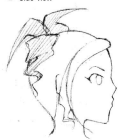

The hairstyle looks quite different from the side.

1. Line art

Alisha is drawn and inked by hand. Varying line widths are important in projecting a sense of space and three-dimensionality (in particular around her feet and shoes). Even though the black outlines may get colored over later on, having the "basis" correct will ensure more ease when shading, and a more powerful image overall.

2. Adding color

Color is added digitally using the watercolor brush in OpenCanvas. Each area is on a different layer so that painting over the lines doesn't matter. If you go over, you can use the Eraser tool to trim the excess. When shading, tick the Preserve Transparency box so that your brush won't add unwanted color to transparent areas.

3. Adding shading

The watercolor brush can be used to mimic a variety of textures. In this image the chiffon shirt, plastic bangle, and metallic bag are all rendered using the same tool. The hair is drawn using many sweeping strokes, allowing the edges to blend together. Coloring the outlines creates an effective subtlety, especially for the necklace chain.

DEMO: SHINY SURFACES

Step 1: The watercolor brush is used to paint the accessories.

Step 2: Adding a touch of skin color under the bangle indicates its transparency.

Step 3: Highlights show the texture of an object. The bangle has soft reflections whereas the gold bag has a brilliant gleam, applied using the Airbrush tool.

030 Geek

See also

*Creating great
line art,* page 18
*Great digital manga
babes: 20 tips,*
page 20

Log on with Lina

Her nanny must have been a computer, because Lina likes to talk to computer screens more than real faces! Her friends do not live in her neighborhood–they are spread all over the planet, connected like a family by the Internet–but she also has a biological family, and when it is time to eat Lina sometimes hears her mother call. But maybe an important e-mail message is due, so Lina forgets her hunger and the people waiting at the table.

Character details

Hair: Her headband holds back her purple hair, so that she can see the screen without any difficulty. The print on the headband reflects her passion for the world of computers, and anyone who shares this passion will understand the signs.

Clothes: She is a girl who cares about hygiene and her body, so she doesn't let herself go completely. She wears comfortable cut-off jeans, a T-shirt, and flat pumps.

Skin tones: Lina has pale skin because she spends so much time in her room on her computer.

Details: Some aspects of her are really geeky, such as the oversized glasses, the pale skin, and the headband.

ABOUT THE COLOR PALETTE

Her hair is purple, with a slight hint of pink. The ballerina shoes have a subtle bronze effect. Her skin is pale, and thus more pinkish. The jeans are washed out, so light gray was added onto the ocean blue color. Instead of using gray for the shadows on the white shirt, a grayish-mint color was used to stop it from being too boring. Bright colors were used for her hair pearls and the headband in order to make the artwork look fresh.

Character studies

Her features are quite delicate, with her big circular glasses mostly obscuring her eyes. Lina is always concentrating on her computer screen, so her tongue sticks out.

○ Head-on view

Her face is finely shaped. To make her look youthful, her face is not totally thin, with the upper half being comparatively large.

○ Three-quarter view

Her eyeglasses are big and circular, with a reflection covering most of her eyes. Her stuck-out tongue indicates that she is concentrating hard.

○ Side view

She has a sweet snub nose and a high forehead. The long hair makes her more feminine.

Artist's shortcut
Scan or trace this:

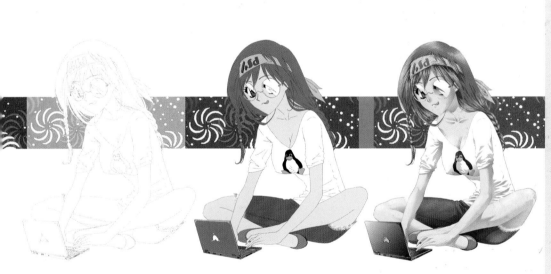

1. Line art
Draw the outlines on a lightbox with a Rotring Rapidograph 0.10. Use tabloid size (A3) satin 90 lb (160gsm) laserprint paper from the high quality brand Neusiedler, because it is smoother than normal copy paper. This ensures that the lines are fine and sharp.

2. Adding color
Scan the line art to 600dpi, black-white (not grayscale). Color the image with the Filling tool.

3. Adding shading
To create her brilliant hair, instead of painting spacious areas with light colors, use the graphic tablet and a small brush to draw many thin lines. If shadow edges are not equally blurred—with some left sharp—it makes the shading interesting and richly contrasted.

DEMO: FABRIC FOLDS

Step 1: Paint shadows with the Brush tool without blurring the edges.

Step 2: Select all shadow parts, and paint some points in a darker color with a blurred brush with low opacity.

Step 3: Take the Blur tool and smudge the edges of the shadows.

031 Retro-kitsch

See also

Great digital manga babes: 20 tips, page 20
Choosing color palettes, page 22

Meet Mimi

A walking fashion statement, Mimi's high-contrast, retro-kitsch styling turns heads wherever she goes. With a passion for electronic music and clubbing, you'll find her out and about every weekend in the most fashionable underground club scenes dancing the night away. Mimi is one cool lady who knows what she wants and does not tolerate anything short of sheer perfection. Approach her in last season's threads at your peril.

Character details

Hair: Jet-black hair offers a dramatic contrast to pale skin and bright red lips.
Accessories: Low-riding headband pushes her fringe downward to cover her eyes, giving her an air of mystique.
Color scheme: Bright pink used for headband, belt, and boots unifies composition and pulls it together.
Details: MP3 player clipped onto belt demonstrates character's passion for music and designer technology.

Tips on this style

Carefully consider the way you pose the character, because this is a very expressive element of the illustration and will speak volumes about her. In this render, the figure is posed as if she were stalking down the catwalk, which is suitable for her exhibitionist personality.

ABOUT THE COLOR PALETTE

Strong colors are a characteristic of manga art. The colors used here attract attention. What's dynamic about the artist's palette is that it uses strongly contrasting colors (pink and black) that punch out when set against the white/gray of the girl's skin and clothing.

Character studies

Initial sketches showed the figure with side-parted hair covering one eye. This helped to make her enigmatic. To enhance her sense of "cool," the artist wanted to make the character standoffish and moody; hence, the deadpan expression.

Artist's shortcut
Scan or trace this:

○ Head-on view

Note the deadpan expression.

○ Three-quarter view

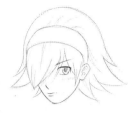

The tiniest of pencil marks stands in for a nose.

○ Side view

Shading gives the figure three-dimensional form.

1. Line art
Manga art relies on sharp, clean lines. Also the preparation of your line art will make the coloring process much easier. This image has been produced on paper before being scanned in ready for inking. Alternatively, you can sketch directly in Photoshop or Painter, then ink the image digitally. The sketch layer is deleted after inking.

2. Adding color
The colors are blocked in using the Brush tools in Photoshop to get an overall impression of the color scheme. This is a chance to experiment with the palette.

3. Adding shading
Light and shade are applied, with special attention paid to the differences between the matte and shiny materials of the clothing. Finishing touches include glossy red lips and the detail on the MP3 player.

DEMO: SHINY SURFACES

Step 1: When the sketch is finalized, scan it into your computer and render it in Photoshop using soft Brush tools (airbrush effect).

Step 2: Shade the shadow area of the hairband using a gradated tone.

Step 3: Give shiny surfaces, such as the satin hairband, white highlights, and blend using the Smudge tool.

Cute youth

See also

Great digital manga babes: 20 tips, page 20
Choosing color palettes, page 22

Presenting Pai

Like many young girls, Pai dreams of being a pop singer one day, and she's so adorable she might just make it. Young and energetic, yet naïve and somewhat dreamy, she spends much of her life daydreaming about the future while dealing with the daily troubles of adolescence. At school she loves history, literature, and music, but hates math and sports. Her mother has connections in the entertainment industry, so Pai also has a job on the side as a child fashion model.

Character details

Hair: Platinum blonde, tied into stylized buns.
Accessories: Hairclips provide a youthful look, and having them on only one side looks stylish.
Color scheme: Both light and dark colors are used, but in such a way as to create harmonic contrast and avoid being hard on the eyes. Skin is soft and pale.
Details: Ribbons, bows, and lacy trims provide a young and innocent look, while the tie is reminiscent of a school uniform.

Tips on this style

It's important to remember when drawing girls like Pai that, while they shouldn't be too childlike, they mustn't be too grown up either. Pai's dress is quite modest, with shoulders covered and a skirt that's not too short, but not too juvenile either. Childlike innocence can also be conveyed in subtle ways, using bows and frills, pigtails, and a hint of blush on the cheeks.

ABOUT THE COLOR PALETTE

Pai wears a cute skirt to create a childish appearance, but to make the dress seem more like something a pre-teen girl would wear, it's more darkly colored—not too sugary cute. Various shades of orange brighten the dress up and keep it from looking too washed out.

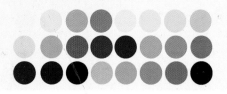

Character studies

Adolescent characters should look slightly superdeformed, but with sleeker, longer, and more angular bodies to indicate their age. Facial features are rounded, but not enough to look deformed. Don't make adolescent bodies too voluptuous, because that will make them look too old.

Head-on view

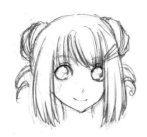

Sweet, energetic smile.

Three-quarter view

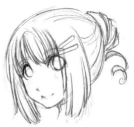

Stylized ox horns or hair "buns" with loose ringletlike strands of hair falling down.

Side view

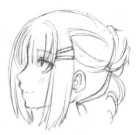

A rounded but defined profile.

Artist's shortcut

Scan or trace this:

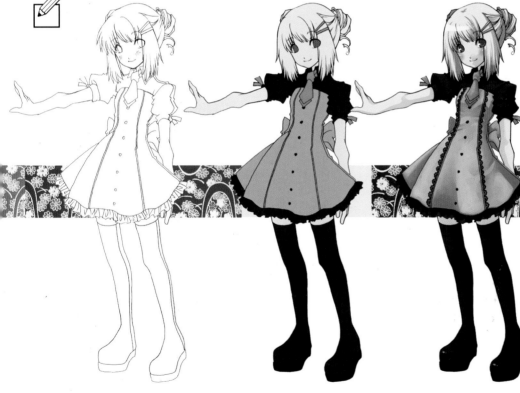

DEMO: CLOTHING

Step 1: Apply the mid-tone colors in blocks.

Step 2: Blur the transitions between light and dark shades by repeatedly eye-dropping the colors in between the shades and applying them where appropriate.

Step 3: Draw in the interesting details, such as lace, by hand. This creates a much more natural look than using predesigned brushes.

1. Line art

The original line art doesn't include all the details that will eventually be added. Start with a simple base sketch of the character, clean it up on the paper by retracing the lines, and give it a final, digital clean up in Photoshop.

2. Adding color

Mid-tone colors are blocked in neatly within the lines of the original drawing.

3. Adding shading

Apply darker and lighter shades of color using hard and soft brushes to give the illustration a sharp but painted look. Darker shades can be applied using the Airbrush tool, set to grainy soft cover. Additional details, like the lace trim on the dress, can be hand-drawn at the end.

Androgynous

See also

Great digital manga babes: 20 tips, page 20
Choosing color palettes, page 22

Meet Heidi

Heidi is a total mystery! At first, no one can tell if she is a boy or girl. The way she dresses and acts really confuses people. Heidi attracts a lot of attention, but she is actually reserved and shy. She loves books, and spends her weekends reading in her back garden.

Character details

Hair: Brown and straight, just long enough to hang over her bright green eyes and add to her general air of mystery.

Skin tones: Her skin is pale, despite those afternoons reading in the garden. She isn't interested in getting a tan.

Accessories: A record bag, scarf, and retro sneakers to complement her band T-shirt and jeans perfectly.

Color scheme: Mostly darker tones, with some lighter colors in the details on her clothes; nothing too bright or noticeable.

Details: Her clothes are mostly loose fitting, making her appear even more androgynous.

ABOUT THE COLOR PALETTE

The deep red-brown coat and blue jeans are close in value, almost drab. The dark blue scarf leads up to the lighter yellowish skin and pinkish-white coat collar. The light areas pop out at us, and the rest of the outfit recedes away, relieved only by bits of bright color on her bag.

Character studies

The character has mostly short hair, but also long strands to create a feminine, or "bishoujo," feel. Her small eyes and wide mouth give her a masculine quality, adding to her androgynous look.

⬤ Head-on view

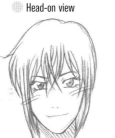

Concentrate on her long fringe falling between her eyes.

⬤ Three-quarter view

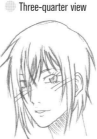

Be sure to keep the proportions of her eyes and mouth consistent.

⬤ Side view

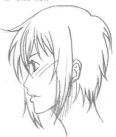

The feminine profile of her jaw line, combined with her wide mouth and small eyes, make her look androgynous.

Artist's shortcut

Scan or trace this:

1. Line art

This character is hand inked, and then scanned into Photoshop. When inking, do not rush; manga is all about smooth, neat lines. If these are achieved, not only will the quality of the picture be better, it will be easier to color in Photoshop.

2. Adding color

Select the areas to color by using the Magic Wand tool in Photoshop, then color the selected area using the Fill Bucket tool. Color the entire figure in this way.

3. Adding shading

The shading is added with the Brush tool. Remember, every surface casts shadows. Using this method creates the traditional CG look. Highlighted areas are important on this figure, as so many of the dark colors are close in value.

DEMO: SKIN HIGHLIGHTS

Step 1: Scan in your work as a black-and-white file into Photoshop. Change it into a color file.

Step 2: Fill in the basic skin color, and decide where the light source is to come from.

Step 3: Using the Brush tool, draw out your shading and highlights, making the character's skin glow.

034 Kindergarten girl

See also

Marker rendering,
page 15
Combining media,
page 17

Say hi to Hoshiko

Other kids complain when they have to walk to school in the rain: not so Hoshiko! Her eyes widen and her heart beats faster with anticipation when she sees raindrops dance in the puddles. She enjoys walking to kindergarten, jumping enthusiastically into every puddle she comes across!

Character details

Hair: She has double-bead hair ties, because they are popular for young female characters appearing in animes and mangas.
Clothes: Her hat and blue shirt are common items of clothing for kindergarten children.
Accessories: Because of the rain, she carries an umbrella and wears a cute jacket and colorful gumboots.
Details: She wears cute star-shaped earrings and has a flower pin on her shirt.

ABOUT THE COLOR PALETTE

Colors associated with candy are used because they match the world of a young, innocent child. Light blue is a common color for the unitary Japanese kindergarten chemise.

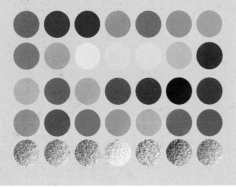

Character studies

Although she is not a chibi, Hoshiko shares many of their exaggerated qualities, such as a very wide-eyed look and a large forehead and head.

Head-on view

The head is domed and extended. The corners of the mouth are also rounded to match with the head's shape.

Three-quarter view

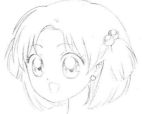

The eyes are large. The iris does not touch the upper eyelid, making the eyes appear very wide.

Side view

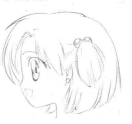

The forehead and the curve of the back of her head are large. The younger a child is the smaller the face is in proportion to the forehead and head shape.

Artist's shortcut

Scan or trace this:

1. Line art

The outlines were drawn on a normal offset, 116 lb (250gsm) tabloid size (A3) paper, with purple Indian ink and a small pen. Colored ink was chosen because it looks cheerful and the contrasts are subtle.

2. Adding color

Because they produce a smooth, uniform surface on almost every paper type, use Letraset Tria Markers for applying base coloring.

3. Adding shading

Continue to use Letraset Tria Markers for the shading. The shadow edges should be sharp, resulting in the artwork looking like a cel-painting of an anime. Use colored pencils to deepen shadows, and, finally white gouache or white opaque ink for the highlights.

DEMO: DETAILS

Step 1: To get an eye with plenty of depth, darken the outer edge and the pupil's edge with little radial lines. Draw radial highlight lines on the middle ring, between the pupil and the outer edge. The iris should become lighter from the top down.

Step 2: If the shadows are darkened to the edge of the base colors, the contrast becomes stronger, making the light seem brighter.

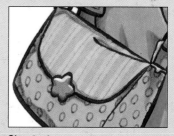

Step 3: If an artwork is mostly composed of plain color areas, enhance it by including details and patterns.

035 Mother and daughter

See also

Marker rendering,
page 15
Combining media,
page 17

Say hello to Abi and Kioko

Abi is a mother and a housewife, even though Kioko's father left just after Kioko, her daughter, was born. Abi is still young at heart and carefree, but also wise and caring. She loves to take Kioko to the park, and Kioko thinks her mommy is a beautiful goddess and wants to be just like her when she grows up.

Character details

Hair: Abi and Kioko share the same bluish dark hair, with a common Japanese hairstyle.
Skin tones: Fresh and healthy to reflect this character's wholesome personality.
Clothes: Abi wears a plain apron and Kioko's dress is green, with a subtle floral motif and a white collar.
Accessories: Abi is shown hanging out laundry so that we know she takes care of the home. Kioko has a toy.

ABOUT THE COLOR PALETTE

The colors are light, subtle, and soft, like pastel. Light blue shadows on a white fabric look cleaner and fresher than gray ones.

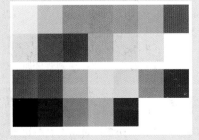

Character studies

This young mother wears her hair loose, but is ready to tie it up in a minute. Her small face is open and loving, with big brown eyes and a happy smile.

● Head-on view

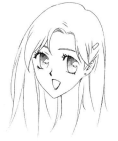

Her eyes are almost too large for an adult, and she has no pupils or irises in her eyes, so her gaze is deep.

● Three-quarter view

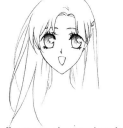

Her cheekbones are indistinct, so the shape of the face is delicate.

● Side view

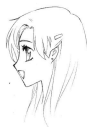

Her chin is pointed; if it were rounded it would look too clumsy.

Artist's shortcut

Scan or trace this:

DEMO: REALISTIC FABRIC

Step 1: For even gradients use satin Neusiedler paper, on which colors look bright and consistent.

Step 2: Hold both markers—the base and the shadow color—in your hands to allow you to swap between them quickly, so work proceeds faster.

Step 3: Use a small, pointed brush for painting detail. Thin out white opaque ink with water to avoid clotting.

1. Line art

The line art is drawn with a Copic Multiliner 0.05mm on a satin Neusiedler color copy paper 80 lb (120gsm) tabloid size (A3).

2. Adding color

Copic Ciao markers are used for the color parts. At this stage, you should write down the color numbers of the markers because they will be used later for the shading.

3. Adding shading

For the shadows use the soft brush tip of the Copic Ciao, because the gradients look softer. Moisten the section where the shadows are to go. Paint over the wet section with a darker marker, and take the base color marker again to blur the edges. Darken some sections with colored pencils and pastel chalk: the basket, the eyes, and some parts of the skin. Paint the highlights, and the pattern on the child's dress, with white opaque ink.

Flower maid

See also

Watercolors, page 16
Choosing color palettes,
page 22

Meet the fragrant Fay

Fay grew up in a poor family, so her start in life was not easy. With no access to education, she had to survive selling flowers until one day she woke up and decided to change her life. Standing before her mirror, she realized that with a makeover and a nice outfit she could be a very beautiful girl. So she scraped her money together, and turned herself into a flower maid. Men could not avert their eyes from her, and as a result many girls were surprised by unexpected flowers from their sweethearts. As her business grows, Fay plans to one day buy her own flower shop.

Character details

Hair: She has strawberry blonde hair.
Skin tones: Pale, rosy skin.
Accessories: She wears a hat, which protects her sensitive skin from the sun. Her summer dress is light and the rendering detailed. A real pattern was drawn on the braiding of the basket handle and her straw hat rather than using simple hatching.

ABOUT THE COLOR PALETTE

Sunny, warm colors are used: yellow, orange, and salmon-pink. This artwork should create a cheery, summery ambience.

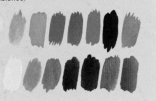

Character studies

Fay has a lot of hair and a hat. Draw her first without the hat, and then add it. Ask a friend to model a similar hat for you, to get the shape right from different angles.

Head-on view

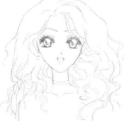

Her eyes are the face's main feature. The lashes and the iris's outer ring are really thick. The oval iris is partially covered by the lower and upper lashes. The way her lashes have been drawn makes her eyes look slightly shut, as if she is smiling.

Three-quarter view

The main highlight in the eyes protrudes into the upper lashes, so her gaze is not dozy. Her rosy lips are curved and become darker at the edges. She has a soft face.

Side view

Her hair is curly, making it quite wild. The ribbon gives her a romantic look.

Artist's shortcut

Scan or trace this:

DEMO: GLOSSY HAIR

Step 1: Paint the strands of hair up to the point where the sheen begins. Wash out the brush and blur the edge between the paint and the sheen.

Step 2: Shadows in the hair are not blurred, so single strands stand out better.

Step 3: Very fine strands are added with opaque white ink for a more delicate look.

1. Line art

Draw the outlines with a brown fine liner Copic Multiliner 0.05 on tabloid size (A3) watercolor paper. Go over the outer silhouette of her body, hair, and dress a second time for more visible lines. Stretch the paper on a smooth board, and saturate it with water. Use watercolor tape to secure the edges. As the paper dries, it shrinks, but the taped edges stretch it, ensuring that it will not ripple when color is applied.

2. Adding color

The color for the whole artwork is painted with Indian ink. Although similar to watercolor, Indian ink is more like water. Also, the ink's brightness remains, even after mixing.

3. Adding shading

Two brushes are used for the gradients on the dress: one clean brush dipped in clear water and another for the Indian ink. Moisten an area with the clean brush, then paint the edge of the wet area with the colored brush; this will be the darkest part. Dip the colored brush in clear water, soak up the surplus water with a towel, and paint further. Continue to do this until a gradient of color is achieved.

Handy girl

See also

Creating great line art,
page 18
*Great digital manga babes:
20 tips,* page 20

Trina says howdy!

Born into a family of ballet dancers, Trina was expected to follow in their footsteps; however, due to a close friendship with her family's caretaker, she soon discovered a talent for handiwork. She finds the smell of newly cut timber and the buzzing of her trusty drill far more gratifying than pirouettes and pliés. With fierce attention to detail, Trina stops at nothing to perfect her craft.

Character details

Hair: Fluffy and feminine. The pink adds an interesting contrast to her working gear. Tied up to keep out of the way when she is working.
Accessories: Her tools are important. Frequent use means she knows their quirks and how to wield them expertly.
Color scheme: Bright, strong colors reflect her energetic character. The pinks and blues hint that despite her chosen line of work, she is all girl!

Tips on this style

When girls take on roles usually associated with men, they are often assumed to be tomboys; keep in mind that this is not always true! A personality that is not a cliché is more interesting!

ABOUT THE COLOR PALETTE

The fresh yellow and orange complement the earthy colors of her skin and hair, while contrasting against her blue trousers. Small details like her eyes and tools are given strong colors to ensure they stand out.

Character studies

Trina's rosebud mouth, large eyes, and halo of pink hair might make her look too vulnerable, but her expression is frank and open. She looks determined to do a good job. No fooling!

● Head-on view

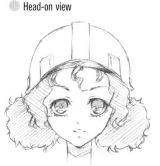

Widely spaced eyes are set about halfway down her face, giving her a younger look.

● Three-quarter view

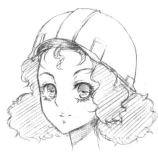

For a convincing character, gaze direction is important. Point the center of the eyes directly at the object observed.

● Side view

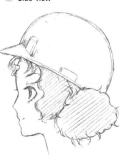

The hard smooth helmet controls her soft, very curly hair.

Artist's shortcut

Scan or trace this:

DEMO: SHADOWS

Step 1: The Airbrush tool is used to create a soft gradient where the shading is less pronounced and to give an indication of where the shadows lie.

Step 2: Use the Pen tool to block in a solid shape of shading.

Step 3: Use the Blur tool to create a soft gradient on one side, but keep the sharp edge on the other.

1. Line art

First, render the line art on paper, and then scan into OpenCanvas for inking and coloring. Because colors and shading—which create an illusion of depth—will be applied separately, the lines should be kept thin and delicate to stop them from drawing attention away from the colors.

2. Adding color

A quick and easy way of adding your base colors is using the Magic Wand tool on your line art layer. Expand the selection by one or two pixels, depending on the thickness of your lines, to get rid of ugly white borders. Each object can be placed on a separate layer, or alternatively share layers to save computer memory, as long as the objects are not directly adjacent.

3. Adding shading

For shading, the OpenCanvas Pen/Pencil tool will provide crisp borders if required; but even soft shading must have some sharp edges for contrast. The shading should be applied on a multiply layer, letting through the base tone, so shadows do not to clash with the base. After finishing shading each layer, the multiply layer is merged with the underlying base color layer, reducing the file size.

038 Secretary

See also

Great digital manga babes: 20 tips, page 20
Choosing color palettes, page 22

Meet Akiha!

Akiha is head personal assistant to the chief executive officer of one of the most prestigious corporate organizations ever, although you would never guess this by looking at her! Akiha's bubbly, upbeat demeanor is not expected from someone in her role. But it is because of this that she is where she is today: by delivering unfaltering professionalism with a charming little smile!

Character details

Hair: Sweeping pink hair for a striking manga effect.
Clothes: Shirt, tie, and sweater combo, complete with pencil skirt, knee-high tights, and pointed pumps. All of them color coordinated to create visual harmony.
Accessories: Designer handbag flung over her shoulder.
Details: Shirt untucked from the sweater-vest creates dynamism.

ABOUT THE COLOR PALETTE

To a charcoal gray skirt and black shoes, Akiha adds a red tie and pale pink shirt that go with her deep pink hair. Her sweater is light gray. The bright green handbag, contrasting with the other close values, sets off the pink and gray theme.

Tips on this style

There are many fashion motifs synonymous with secretaries, such as the shirt, tie, and pencil skirt. These need to be included to get the basic look correct. However, certain items included here, which are atypical of the secretarial look, make this character unique—for example, the sweater vest coming off the shoulders, the short, fat tie, the high tights, and, of course, the crazy slicked-back pink hair! The pink and gray color scheme is soft and feminine, and helps her to retain some elegance.

Character studies

Although Akiha is young, she is serious about her job. Her carefree attitude and disarming smile are part of a responsible woman! Her windswept hair and shiny pink cheeks reflect her boundless energy.

Artist's shortcut
Scan or trace this:

○ Head-on view

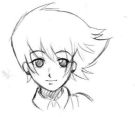

Keep her eyes round and bright, and don't forget the ears.

○ Three-quarter view

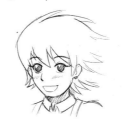

See how the open mouth here changes the shape of the face from the closed mouth front view.

○ Side view

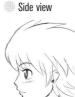

From the side, she looks like a resolute heroine.

1. Line art
Because Akiha is a secretary, it is important that the line art is simple, communicating a pared-down, practical look associated with business. As usual, ensure everything is in proportion before proceeding. This saves time.

2. Adding color
The point here is to keep things relatively simple, so the color palette is kept to a minimum. The soft combination of pink and gray is used because they work well together.

3. Adding shading
In keeping with the simplistic theme, only one shading layer is applied. This keeps things nice and clean, and provides a sharp, cel-shaded look. Soft brushes, or airbrushing, should be avoided, because they would work against the hard edges. Highlights should also be kept to a minimum, with only a few subtle white flecks to accentuate the shine in her hair and shoes.

DEMO: SHINY LEATHER

Step 1: A lot of fine detail should go into the handbag, because it is her only proper accessory. Start with the basic shape of the bag.

Step 2: Add the details, such as the stitches and the clasp. This will help to make the bag look more authentic.

Step 3: Color and shade, as usual. Hard shine lines, as shown here, help to give the bag a shiny leather look.

Cook

See also

Watercolors,
page 16
Combining media,
page 17

Get cooking with Cho

Cho is a young, ambitious Japanese chef, and her greatest desire is to be a cookery star on television. However, her enthusiasm outweighs her skill. As she dreams of a life of stardom, the thrashing fish slips from her hands and escapes. She chases the fugitive fish with the battle cry "Banzai!" She is more like a martial artist than a professional cook!

Character details

Hair: Cho's long loose hair flies around her as she dashes about the kitchen.
Accessories: As a chef, Cho's outfit wouldn't be complete without a traditional chef's hat and jacket and, of course, a cleaver.
Details: Cho is holding a fish and is clearly struggling to keep a grip on it, giving the image an anarchic feeling.

Tips on this style

Cho is drawn in a shounen style (a manga drawing style for boys), because she has a dynamic pose, and it matches her character. Shounen-style figures have smaller eyes compared to shoujo (a manga drawing style for girls), and there are fewer glitter points in her eyes. The body and face are less delicate, and the musculature is more prominent.

ABOUT THE COLOR PALETTE

A cook's outfit is usually white, so that is what Cho has been given. The red hems, buttons, scarf, and her black hair are traditional Japanese colors. The pants are light olive-green, which prevents the artwork from becoming austere. The fish color is a mix of salmon-pink, blue-green, and grayish dark blue, painted in layers on wet paper.

Character studies

Although she's drawn in the shounen style, Cho still looks feminine and elegant. Her expressive eyelashes and eyebrows, in particular, give her a ladylike look.

Artist's shortcut

Scan or trace this:

○ Head-on view

Her upper eyelashes arch toward her temple giving her a cheeky aspect. The crooked edges of her mouth add to this cheeky expression.

○ Three-quarter view

She has an unusual haircut. The hair on top of the scalp is cut straight, just under the ear, and the fringe is a little shorter. The hair on the lower portion of her head is long and also cut straight.

○ Side view

Her nose turns up sharply at the end, and her face is angular. The wide space between her eyebrows and eyelids makes her look elegantly ladylike.

DEMO: HAIR HIGHLIGHTS

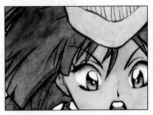

Step 1: Painting layers of watercolors over each other can create fascinating color effects; laying gray-brown over purple produced the hair color.

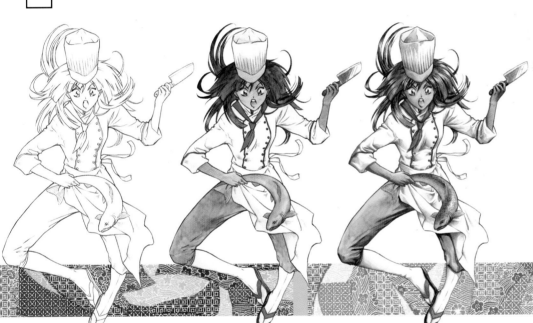

1. Line art

Draw the sketch on letter size (A4) copy paper, and then trace it, using a lightbox, onto tabloid (A3) 110 lb (220gsm) watercolor paper in a slightly yellow shade. Use waterproof color pencils for the outlines in preparation for watercolor paints—first, a dark green pencil and over that dark violet. These different colors make the outlines more interesting.

2. Adding color

For coloring areas within the lines, apply watercolor using a pointed watercolor brush with real hair.

3. Adding shading

Undiluted gouache should be used for the shadows; be aware that because it is water-soluble, gouache cannot be applied in layers. It is easier to paint the lighter sections, because white can be blurred with water without creating streaks. The pants were highlighted with light yellow. The fish was painted light greenish-blue, with white added over the top.

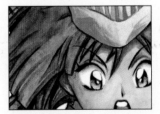

Step 2: The same grayish-brown watercolor was used for the shadows in the hair.

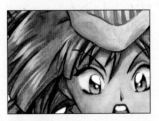

Step 3: To create the hair's brilliance, a light blue gouache was used first. When it dried, white gouache was added to create a gloss effect.

Sportswoman

See also

Colored pencils,
page 14
Marker rendering,
page 15

Work out with Stacey!

Stacey loves sports, being active, and keeping fit. She is not skinny, nor is she outrageously curvy; she has toned arms, strong legs, and a flat tummy. Tennis is one of her favorite sports–not only are the outfits cute, but tennis satisfies her competitive streak. You can see in her face that she hates to lose! Although she is an avid sportswoman, she still likes to look very feminine; hence, her choice of pretty pink accessories.

Character details

Hair: Tied up in a high ponytail, and tucked above the back strap of her sun visor.
Clothes: A fitted tank-top and pleated tennis skirt for maneuverability and keeping cool.
Accessories: Her trusty tennis racket and a big sports bag for all her gear.

ABOUT THE COLOR PALETTE

As a mixed media piece: use markers for the lighter colors and water-soluble pencils for the darker colors. It is good to have two to three shades per color and a clear solvent pen for blending.

Character studies

Stacey's pointed chin and long nose frame a wide mouth. Her lips are pressed together in determination, and her wide-set eyes are always looking for openings. Her eyes are intense.

○ Head-on view

It can sometimes be tricky to draw a high ponytail if viewed front-on.

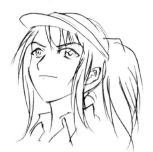
○ Three-quarter view

Show off that smirk when she wins a volley!

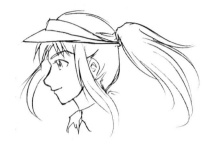
○ Side view

Consider the movement of her hair.

Artist's shortcut

Scan or trace this:

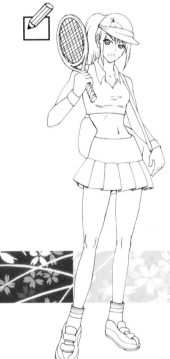

1. Line art

Stacey is penciled on paper using 0.5 mechanical pencils. Ensure that details are clear and sharp. She is inked with 0.05 and 0.1 fine liners in black, with subtle line weight variation. As this is a natural media piece with Deleter Neopiko Markers and water-soluble pencils, ensure your inks are markerproof and waterproof. Take care to erase all pencil marks to avoid smudges.

2. Adding color

To create soft blends and gradations, coloring and shading should happen one element at a time, as opposed to laying all the base colors down in one go. Markers dry quickly, so blend when the paper is wet. Start with the skin tone, or any other part of the picture with comparatively light colors.

3. Adding shading

If sharp shadows are required, work from light to dark, letting each layer dry. If soft shadows are required, work from dark to light while the layer is still wet. Leave lots of paper white for a sun-drenched look with strong contrast. Use colored pencils to add definition to the darker shadows. Treat water-soluble pencils like markers—for defined shadows, work when the layers are dry. For soft blend, use the pencils, and then go over with the marker.

DEMO: SKIN AND HAIR

Step 1: The skin is a little undefined; adding brown pencil will give it more contrast.

Step 2: Use the brown pencil to bring out features, and add depth to the darker shadows.

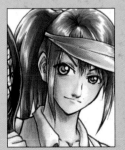

Step 3: Colored pencils are great for creating fine strands of hair.

041 Pop idol

See also

Marker rendering,
page 15
Combining media
page 17

Go crazy with Chika!

It's the mid–1980s. Chika is only nineteen, and is already at the top of the charts with a self-penned pop song. Her music education started with classical piano lessons but there is fire in this girl's belly, and only rock music allows her to express it adequately; pop is not the style of music she lives for! However, she has a keen business mind, and she gives people what they want to hear in order to earn lots of money. One day she will break free to create the music she really loves.

Character details

Hair: Big eighties hair: thick and curly, dark brown with a hint of red.
Accessories: A microphone and microphone stand, essential for a pop idol.
Details: From the pixie boots to the star-shaped earrings, Chika is a picture of eighties pop. Also, a spotlight shines from behind her head, adding to the impression that she is on stage.

Tips on this style

She wears stylish clothes, characteristic of the 1980s; denim, leggings, miniskirts, armlets, and pointed boots were all fashionable back then. Most shirts and jackets were cut wide at the sleeve and at the shoulder and tight at the cuff, as here with Chika. Patterns on material are angular and futuristic.

ABOUT THE COLOR PALETTE

Colors used in the 1980s were often garish and combined with black. Color combinations, such as pink, ocean-blue, purple, and neon-green were popular. Combinations of base colors (yellow, blue, red, green) were rarely seen, as were more discreet colors (brown and gray).

Character studies

Chika has a girl-next-door look that would appeal to her mostly young and female fans: a sweet smile and large innocent eyes.

⬤ Head-on view

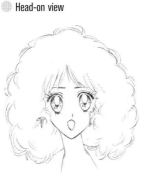

Her chin is delicate, and her smile is sweet. She has a long, slender neck.

⬤ Three-quarter view

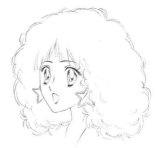

The lips are thin and glossy. She has oval eyes, and the lower lashes are thick.

⬤ Side view

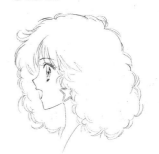

In the 1980s fuzzy hairstyles with a layered cut and small curls were trendy.

Artist's shortcut

Scan or trace this:

DEMO: HIGHLIGHTS

Step 1: Her hair was painted with several layers of ink. To achieve a blotched effect the area was moistened, and ink was dabbed on with a brush.

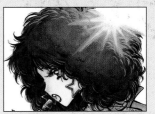

Step 2: Pinkish-white opaque ink was used for the spotlight's shine above her head, and this was painted over with white opaque ink.

Step 3: Adding a lighter color on the sharp-edged boots makes them glossier.

1. Line art

Use a tabloid size (A3) 116 lb (250gsm) watercolor paper sheet because colored Indian ink looks great on it. Use black Indian ink and a small pen for the outlines. Pay attention when using a high quality Indian ink! Lines may smudge when painting with watercolors or colored Indian ink.

2. Adding color

Use Tria markers for the color sections, because they work well on watercolor paper; areas color uniformly and are waterproof.

3. Adding shading

Indian inks have the advantage of being waterproof. White opaque inks are used for the highlights. To create the spotlights behind her, white opaque ink was mixed with gouache to increase its viscosity. In order to reflect the spotlights, lines were drawn down her body; on her left, a light green line and on the right a pinkish one. Fine liners, and gel roller pens were used for the miniskirt pattern.

042 Cowgirl

See also

Watercolors,
page 16

Saddle up with Sandy

Sandy is a born-and-bred cowgirl, having grown up on a ranch in Texas where she learned how to ride horses and tend cattle. Like all cowboys she owns a revolver, but keeps it hidden under her bed and only uses it in emergencies. She's high-spirited and hot-blooded, but aggression doesn't suit her carefree nature, and after a hard day working on the ranch she loves going to local bars to dance and flirt.

Character details

Hair: Sandy's hair matches her character—fiery red and a little bit wild. She's styled it into braids to keep it from getting in the way while she works.

Skin tones: Because she spends all her time outdoors, she has a warm, even tan.

Accessories: A cowboy hat is essential for working under the hot Texan sun, and the leather wrist cuffs are a cute alternative to gloves.

Color scheme: Mainly shades of brown, with other colors used sparingly for contrast.

Details: Sandy's checked gingham blouse and tassels on her jacket, belt, and wrist cuffs add a flavor of the Wild West. Remember to add studs or large stitches around any leatherwork on her jacket, belt, or boots.

ABOUT THE COLOR PALETTE

Sandy's outfit involves a lot of leather, so a wide variety of shades of brown is important. Bright oranges and reds will work well in this color scheme, but add some blue to keep the image looking fresh.

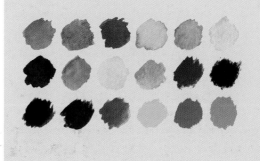

Character studies

Although she's ladylike, it's important to remember that Sandy is a hard, manual worker. Be sure to strike a balance between these two qualities.

● Head-on view

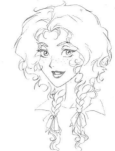

Freckles and braids add a "girl next door" quality.

● Three-quarter view

Keep the lips well defined and the upper eyelashes thick to give her a feminine look.

● Side view

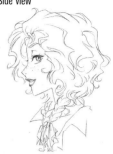

Her pout is very clearly defined from the side. Remember to keep the volume of her hair consistent.

Artist's shortcut

Scan or trace this:

1. Line art

Make a pencil sketch on a letter size (A4) sheet of paper before enlarging it to tabloid size (A3) on a photocopier. Use a lightbox to trace the sketch onto watercolor paper with a black ballpoint pen.

2. Adding color

Add the base colors using watered-down watercolor paints—these provide a good base texture for leather clothes. Paint details like the check pattern of her blouse with a very fine-tipped brush.

3. Adding shading

Use gouache paint, which is more opaque than watercolor paint, to apply shading and highlights. Dark gouache paint dries lighter and light gouache paint dries darker, so don't worry if the colors don't seem quite right when you apply them.

DEMO: FEATURES

Step 1: Apply base colors using a round, natural hair paintbrush with a pointed tip.

Step 2: Add shade using gouache paint. Keep using a brush with a pointed tip.

Step 3: Finally, apply highlights using opaque white gouache.

Tips on this style

It's important to remember the lifestyle of your character when drawing a girl like Sandy. Her clothing needs to be practical for living and working on a ranch—light and nonobstructive—while her body should be tanned and muscular, but be careful not to make her too well built.

043 Wrestler

See also

*Great digital manga babes:
20 tips*, page 20
Proportion and scale,
page 24

Slam down with Hikari!

Conquering wrestlers around the world has been Hikari's dream ever since she saw her idol, Mysterious Dragon Mask, win the Japanese female championship when she was a child. She grew up pursuing the lofty dream of being the best of the best, and procuring the legendary Dragon Mask for herself. Although still an amateur, Hikari's resolve is unbreakable, and she will get up every time she is slammed to the mat.

Character details

Hair: Short, tomboyish blonde hair.
Details: Provocative wrestling victory pose.
Skin tones: Light perspiration makes skin glossy.
Clothes: Skin-tight, latex wrestling outfit.

Tips on this style

The priorities are the pose and the anatomical structure of her body. Producing a dynamic pose like this is not always easy; take time to ensure that she does not look odd or disjointed. A minimal wrestling outfit was decided on, keeping the piece simple. This provides the chance to hone skills in shading and highlighting skin, which is not possible with a fully-clothed character.

ABOUT THE COLOR PALETTE

Hikari's light hair contrasts with her skin, which has been tanned to the color of coffee with cream. The careful highlights on her skin and suit follow her contours. Smooth and cool in sky blue latex accented with white stripes, she is as streamlined as a shark.

Character studies

Hikari has a short boyish haircut and doesn't seem to wear any makeup, but her features are still very feminine. She has large, almond-shaped eyes and a small nose and mouth.

Artist's shortcut

Scan or trace this:

● Head-on view

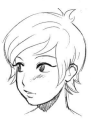

Place the features precisely here, starting with the eyes and the space between them.

● Three-quarter view

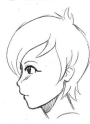

A "portrait" view reveals both head shape and personality.

● Side view

Her profile shows a slight overbite, so her upper lip protrudes.

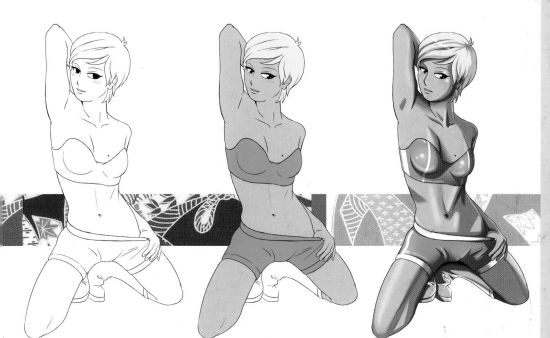

DEMO: LATEX

Step 1: To render the shiny latex look of her outfit, first prepare the line art and the base color coat.

Step 2: Add a layer of shading. Apply shade with a soft brush to emphasize contours and use a hard brush where shadows are cast by another object.

Step 3: Create reflections by adding in white highlights with a soft brush, loosely mapping out the shape of her figure accordingly.

1. Line art

Getting the pose anatomically correct, without making her look disjointed, is probably the biggest challenge here. It helps to get the sketch just right before going ahead and committing the outline.

2. Adding color

A darker, tanned skin color is used to reinforce the character's outgoing, athletic nature. The outfit has a single color throughout, like real wrestling outfits, helping to make the wrestler more noticeable from a distance.

3. Adding shading

The main focus here is skin tone, because that is what is primarily on display. Here we see four grades of shading, from the white shine to the shadows. This is necessary in order to emphasize the body's contours and to give the skin a glossy, sweaty effect.

044 Diva

See also

Marker rendering,
page 15
Combining media
page 17

Sing and dance with Davina

As a child, Davina would watch divas on television. She was fascinated by their costumes, dancing, and singing. Years later, her own mysterious beauty and expressive voice have brought her fame. After years of work, she became the singing star she had longed to be. Here she poses for a full-page magazine advert for her own scent!

Character details

Clothes: She wears a beautiful, elegant silk dress.

Skin tones: Deep, dark brown.

Accessories: The feather stole widens her shoulders and gives her an extravagant appearance. Shiny pearls add to the luxuriant effect, and peacocklike feathers lend an exotic touch.

Details: Extravagant and elegant shoes with panels that extend up her calves. The flacon of perfume that she holds is as elegant and luxuriant as her appearance.

ABOUT THE COLOR PALETTE

Her silk dress is white, with pale salmon-pink. The white stole has a slight purple touch, but not bright enough to clash with the salmon-pink. The pearls are also salmon-pink, but with a shimmer of gray-green. To make the colors stronger, green-blue and golden-yellow were applied.

Character studies

Davina has a heart-shaped face with a pointed chin and half-closed eyes, giving her a haughty and languid look simultaneously. Her elaborate hairstyle complements her face shape.

Artist's shortcut

Scan or trace this:

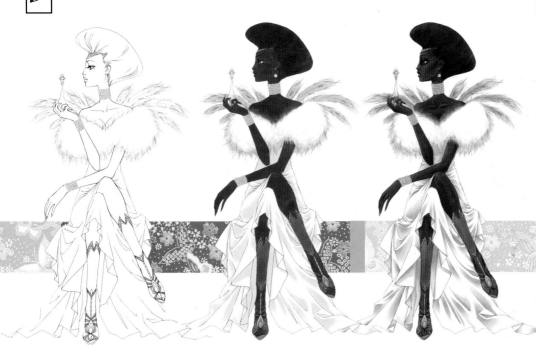

○ Head-on view

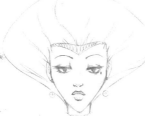

She has smoky, bedroom eyes; her eyelashes are long and dark.

○ Three-quarter view

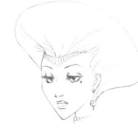

She has characteristic cheekbones, pointed out by rouge shadow, making her face elegant and angular.

○ Side view

Her lips are full and sensual; the hairstyle is extravagant, the forehead is high and curved, and the nose is flat.

1. Line art

Draw the outlines on 80 lb (120gsm) tabloid size (A3) satin Neusiedler color copy paper with Copic Multiliner pens. For the feather stole and pearls a sanguine fine liner is used for strong lines.

2. Adding color

Use Copic Ciao markers for the color parts and remember to write down the numbers of the markers used for future reference.

3. Adding shading

For soft shadows, take the soft brush tip of the Copic Ciao. Moisten the part reserved for the shadow, like an undercoat. Then paint over the wet part with a darker marker and use the base color marker to blur the edges. A black crayon can then be used to draw lines of shadow in her hair and white crayon for the highlights on her skin and boots. Use a lila crayon to draw fine lines around the feathers.

DEMO: REFLECTIONS

Step 1: First, color the pearls with pale salmon-pink.

Step 2: Paint between the pearls with a dark salmon-pink. On the spots where highlights will be placed later, add a spot of gray-green. Paint a second reflection on the larger pearl.

Step 3: Finally, paint opaque white ink in the middle of the gray-green spots. Now the highlighted dots have dark rings around them creating greater contrast.

045 Teacher

See also

Great digital manga babes: 20 tips, page 20
Choosing color palettes, page 22

Say good morning Ms. Appleton!

Ms. Appleton is well known for her stern approach to education and having no tolerance of anything imperfect. A multidisciplinary woman of extraordinary talents, Ms. Appleton does not specialize in any particular subject: she specializes in them all! From physics to math, from gym to art, from Latin to German, this lady's knowledge and skills are beyond comprehension. She is also a black belt in various martial arts. This is one teacher you don't want to mess with!

Character details

Hair: Purple hair in a bun, with cute hair clip.
Details: Trendy, rimless glasses, jade earrings, and oversized antique jade brooch.
Clothes: Top-buttoned cardigan. Detailed black lace stockings. Metallic high-heel glamour shoes.

Tips on this style

Ms. Appleton is a mature character so her fashion should be appropriate. A respectable shirt and cardigan is in place, juxtaposed with a short, yet elegant, pencil skirt.

ABOUT THE COLOR PALETTE

Teacher is dressed in pure colors: the primary colors of red and yellow and the secondary colors of purple and green. Her skin has an orange tint. Her clothing is simple, but the long black stockings and yellow-and-black shoes compete for attention with her antique brooch, glasses, and her bright purple hair.

Character studies

Her small face is topped by a high bun and sideswept bangs with loose hair on either side. Her glasses perch on her nose below her eyes. Her eyebrows are drawn into a frown of concentration. Don't forget the tiny mole on her left cheek.

Artist's shortcut

Scan or trace this:

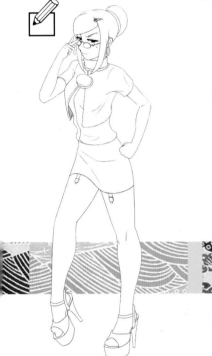

● Head-on view

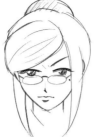

The many elements to balance on this face are: eyes, glasses, mole, nose, mouth, and hair.

● Three-quarter view

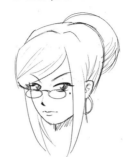

An ear with an earring shows, and from her expression she is watching something.

● Side view

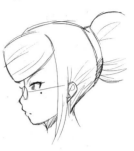

The hair is simpler here, and you can see the mole on the cheek clearly.

DEMO: LACE

Step 1: Fix the color on a lacy pattern until it is black on a light background, either by Hue and Saturation or Invert in Photoshop.

Step 2: With the Lasso tool, cut out a strip of lace, paste it onto its own layer, and position it in the desired position. Delete the previous layer to avoid cluttering.

Step 3: Using the Warp tool manipulate the onscreen mesh until it is in the correct position. Once it is in place, invert the layer and adjust the level until the background is invisible.

1. Line art

Use clean, crisp lines for this character, with plenty of detail to make her come alive. Pay attention to the face, and ensure the expression is right—suspicious and disapproving, but not angry.

2. Adding color

Several colors are applied at this stage. Feel free to try any color combination desired, but keep them slightly unsaturated and warm to get a sense of maturity; but make sure the colors are not dull.

3. Adding shading

By using a mixture of soft-and hard-edge brushes, the illusion of different materials can be created. For example, a soft brush is applied onto the woolen cardigan and a harder brush is used for the stiff cotton shirt. To achieve the metallic-looking shoes, apply a line of darker shade parallel to where you have articulated the shine. This will give the impression of reflecting chrome.

Nurse

See also

Colored pencils,
page 14
Marker rendering,
page 15

Say ahh for Nina

Nina may appear to be a highly motivated nurse, with a caring bedside manner, but appearances can be deceiving. In fact, she is a ruthless practical joker who enjoys playing tricks on the other nurses and telling tall stories to the patients, enjoying the dumbfounded expressions she elicits from her victims.

Character details

Hair: Light lilac to suit her sassy personality and to keep her from seeming too dull and mundane.
Clothes: A variation on a traditional nurse's uniform with saucy additions such as stockings and a choker.
Accessories: A first aid kit and a syringe.

ABOUT THE COLOR PALETTE

Nurses wear white. Red matching lines on her clothes and shoes were added to reflect the Red Cross. In order to avoid the costume looking too boring, her dress is striped, and a fresh, clean light blue is used. Giving her light blonde hair was considered, but rejected for being too banal. However, brownish and yellowish colors were to be avoided because they are not as clean and fresh as blue and white. Light lilac was used as a base color on her hair.

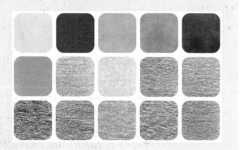

Tips on this style

Her outfit is modeled on an old-fashioned nurse's uniform, but due to the low neckline and short skirt it is not as modest. It is influenced by the gothic Lolita style. The stockings, striped dress, and neckband are drawn from the Moulin Rouge fashion.

Character studies

Nina has very large eyes. Combine them with her hair and you have the major part of her head completed. Lively hair shows spirit and personality. Arrange it on the head as a few large masses, and then break those down further with increasingly fine divisions.

Artist's shortcut

Scan or trace this:

⬤ Head-on view

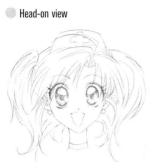

Her large eyes and laughing mouth make her look youthful.

⬤ Three-quarter view

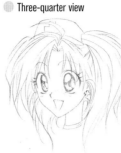

Her hair looks sassy and cute.

⬤ Side view

Her face shape is angular and wide. The upper half of her head is large.

1. Line art

Using smooth cartridge paper, 100lb (200gsm) in tabloid size (A3), and a sanguine colored fine liner (Copic Multiliner) 0.05mm, trace the outline of your character on a lightbox. Then use a thicker sepia-colored fine liner on the outer parts of her body and clothing. On finer internal lines use a 0.3 sanguine fine liner.

2. Adding color

For her skin, hair, and red sections, use Tria markers by Letraset. Because they create the smoothest surfaces, with no streaking, they are ideal.

3. Adding shading

Add shading with colored pencils, ensuring they are sharp, in order to get exact edges on the shaded areas. Colored pencils do not provide the same darkening effect when applied in layers as watercolors or Indian ink. To counteract this, when laying in the shadows in the dress, a darker blue-colored pencil should be used over all stripes lying within the shaded areas.

DEMO: STRIPED FABRIC

Step 1: For the striped dress mix blue and green Indian ink with water, and paint the stripes with a pointed, real-hair brush.

Step 2: Shadows are drawn with sharp edges, rather than letting the color phase out, similar to the cel works in anime cartoons.

Step 3: In order to deepen the shadows they are painted over again with a darker, different-colored pencil.

047 Satsuki in the snow

Say hi to Satsuki

Satsuki loves snow and, as she heads to school she's overjoyed that the first snow is falling. She's wrapped up warmly in her winter school uniform, a warm coat and pink scarf, but she's still a fashionable girl at heart, choosing to go bare-legged with large, loose socks. Cheerful though she is now, she's forgotten that there's bound to be a snowball fight in the playground, and her bright pink hair makes her a prime, unwilling target—not that she can't throw a few snowballs back herself!

Character details

Hair: Outrageous, shiny pink tresses.

Skin tones: Pale skin with rosy cheeks.

Accessories: School satchel, loafers, and loose socks are part of the regulation uniform. Many schoolgirls customize their look with accessories, in this case a pink cashmere scarf and short coat with a Lolita-style (see page 27) heart pocket.

Details: SD (superdeformed, see page 11) proportions are characterized by an oversized head and facial features. The body usually takes up two head lengths, making the finished character three heads tall.

(see page 27)
(superdeformed, see page 11)

DEMO: HAIR TONES

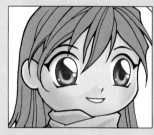

Step 1: The hair should be a tone and color that complements the rest of the image.

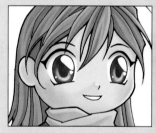

Step 2: Shading is applied using the watercolor brush. Sweep on thin strokes of varying shades to create a realistic impression of hair strands.

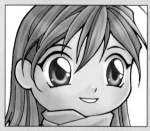

Step 3: Highlights are added using an addition layer. You can achieve a similar effect in Photoshop using the Dodge tool.

ABOUT THE COLOR PALETTE

Because of their cute appearance, SD illustrations are well suited to pastel color schemes. Pastel tones are ideal for beginners because all colors go together without clashing. Mix and match pastels to create unique combinations.

 Head-on view

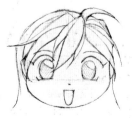

Eyes and mouth dominate the face. The nose and cheeks are compressed because they aren't expressive.

Three-quarter view

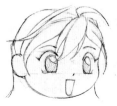

If you put in too much detail the result may look like a normal child character rather than an SD.

Side view

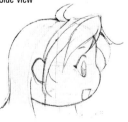

Due to perspective, the eye further away is narrower. This is most apparent in SD-style because of the large eyes.

Little Ms. Mitsuki

Mitsuki is pleased to meet you

Mitsuki may seem like a normal ten-year-old, but in reality she's the princess of Pikari Land, a magical kingdom in another dimension. In Pikari Land all children of royal blood are sent out into the world once they reach the age of ten, where they have a year to make all their dreams come true before returning to the kingdom to study the harsh world of politics. With her faithful henchmen Mitsuki has set out with big dreams, and her sweet smile and happy-go-lucky attitude mean that she's adored by everyone she meets.

Character details

Hair: Chocolate brown, layered, and styled to look slightly messy, in keeping with Mitsuki's free-spirited nature.

Skin tones: Warm and tanned, but just pale enough to accentuate the blush on her cheeks.

Accessories: The puffy newsboy cap, two crossed-over belts, and leather collar are cute and stylish at the same time.

Details: Despite her noble blood, Mitsuki has adopted a casual, urban look to strike a balance between comfort and style. This balance is most crucial in her boots, which have platform soles to make them stylish but have been designed to be hard-wearing.

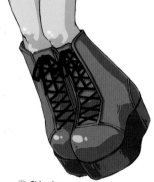

ABOUT THE COLOR PALETTE

Compensate for the need to use a simplified character design by having a bright, eye-catching color palette. Although Mitsuki's palette mainly consists of brown and beige shades, the warm peach colors of her dress and cap and bright green of her eyes add life to the drawing.

DEMO: SKIN TONES

Step 1: Apply a block of base color using the Pen tool on Painter.

Step 2: Use a darker shade of the base color to create shadows and give a sense of depth. Continue using the Pen tool because it creates a cel-shaded effect.

Step 3: Add color to the lips and cheeks by applying a light, reddish-pink tint using the Airbrush tool. Finish by adding white or pale yellow speckles as highlights.

⬤ Head-on view

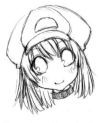

Remember to keep details rounded. Don't draw a nose as it overcomplicates the face.

⬤ Three-quarter view

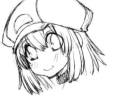

From this angle, the nose should be visible, but don't add it to the line art–create it during the coloring and shading stages.

⬤ Side view

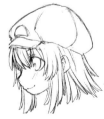

Here the nose is clearly visible as part of a simplified, rounded profile.

049 Dark elf

Meet Morwenna

Morwenna is cool, aloof, and distant. Cunning, shrewd, and ever-so-slightly cruel, she is a denizen of the night, at home in forests and caves. She is an expert huntress and fierce fighter, but is more than happy to use her otherworldly beauty in order to get her own way. Even in a chibi version her attitude still shines through!

Character details

Hair: Pale, white, and shiny, with fine tendrils.

Clothes: She is a Dark Elf, so her clothing is mainly black and skin tight. She has fur accents on her shoulders and boots.

Weaponry: An expert archer, she carries a bow and quiver engraved with mystical symbols.

DEMO: FINESSING

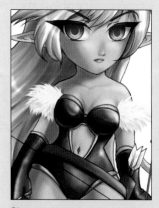

Step 1: OpenCanvas has a useful addition layer to create lovely highlights and overlay effects. This is great for eyes, hair, and patterns.

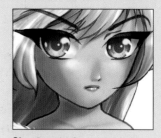

Step 2: Add fiery highlights to her eyes.

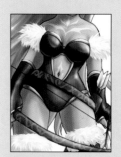

Step 3: Jazz up her skin with tattoos and her bow with patterns.

ABOUT THE COLOR PALETTE

She has dark skin and pale hair. Because she is a creature of the night, do not go for saturated colors. Use a washed-out brown for her skin and a series of cool grays, with indigo and purple tinges, for her white hair.

● Head-on view

Note her long ears, not angled high but straight out from her head.

● Three-quarter view

Vigilant, catlike eyes with a tress of hair falling between them.

● Side view

Keep her eye shape consistent from all angles.

Pixie

Say hi to Pippa the Pixie!

Pippa is a cute little flower pixie—sweet and playful, curious and changeable! A carefree creature, she dances through forest glades, bouncing on petals, drinking dew, and taking naps under shady ferns. This mercurial lifestyle means she is easily distracted and cannot sit still for very long. Count yourself lucky if you get a glimpse of her, as something else will inevitably catch her eye and off she'll go in pursuit!

Character details

Hair: Cute, short, blonde, and a little spiky, it is covered by a rose flower cap.
Clothes: She wears a yellow suit, with little leaves at the top and bottom. She has adorable little pixie sandals with curly toes and ribbon ties.
Wings: Her little wings are iridescent, semitransparent, and change color in the light.

ABOUT THE COLOR PALETTE

Although the base colors and initial shadows are quite warm, it adds a level of sophistication if your darker shadows hint at a cooler backlight. Thus, yellows are closer to the light source and blues are further away.

DEMO: IRIDESCENCE

Step 1: To make the wings iridescent, start by generating a cloud pattern using Photoshop's filters.

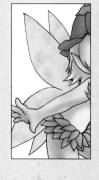

Step 2: In a layer underneath the cloud pattern, use a Gradient tool to add a rainbow pattern.

Step 3: Set the cloud pattern layer to hard light, so that the shading in the cloud picks up some of the rainbow pattern below.

Head-on view

Three-quarter view

Side view

Make her eyes look as big and sparkly as you can!

Do not forget the position of the rose flower cap, and make sure the petals curl up at the edges.

Be careful when drawing her eyes in profile.

Index

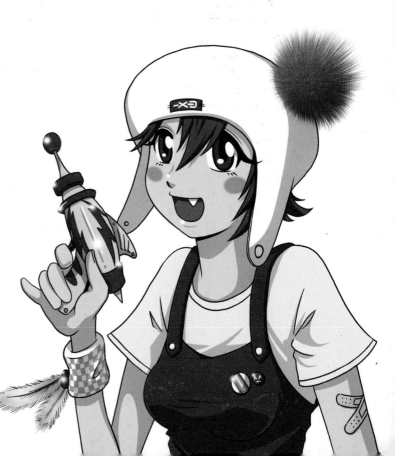

Credits

Quarto would like to thank and acknowledge the following for supplying photographs and artworks reproduced in this book:

Key: t = top, b = bottom, l = left, r = right, c = center

Dentsu/Nippon TV/ The Kobal Collection: 11

Emmanuel Faure/ Iconica: 27t

Ippus *www.ippusuru.net*: 36, 37, 38, 39, 92, 93, 123

Janet Benn: 25t, 26, 27bcl, 27br

Joanna Zhou *www.chocolatepixels.com*: 66, 67, 86, 87, 122

Manga Entertainment/ The Kobal Collection: 10

Nana Li *nanarealm.com*: 44, 45, 102, 103

Sonia Leong *www.fyredrake.net*: 46, 47, 48, 49, 52, 53, 60, 61, 72, 73, 108, 109, 124, 125

Sumit Sarkar *www.kriksix.com*: 6, 8, 74, 75, 80, 81

Suzanne Lam *www.dblstudio.com*: 42, 43, 50, 51, 78, 79, 84, 85, 94, 95

Viviane *www.viviane.ch*: 32, 33, 34, 35, 56, 57, 58, 59, 70, 71, 76, 77, 88, 89, 96, 97, 98, 99, 100, 101, 106, 107, 110, 111, 112, 113, 116, 117, 120, 121

All other illustrations and photographs are the copyright of Quarto Publishing plc. While every effort has been made to credit contributors, Quarto would like to apologize should there have been any omissions or errors—and would be pleased to make the appropriate correction for future editions of the book.